HEATH ROBINSON's
GREAT WAR

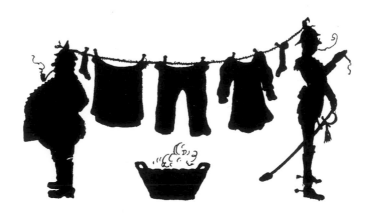

This edition first published in 2015 by the Bodleian Library
Broad Street
Oxford OX1 3BG
www.bodleianshop.co.uk

ISBN: 978 1 85124 424 9

Original material reproduced from the following volumes by Heath Robinson:
Some 'Frightful' War Pictures, 1915
Hunlikely!, 1916
The Saintly Hun, 1917

This edition © Bodleian Library, University of Oxford, 2015
Introduction © Geoffrey Beare, 2015

Designed and typeset in 12/17 Obelisque by Dot Little at the Bodleian Library
Printed and bound in China by C&C Offset Printing Co. Ltd on 157gsm Chinese Huaxia sun matt art

British Library Catalogue in Publishing Data
A CIP record of this publication is available from the British Library

CONTENTS

PREFACE

The term 'Heath Robinson' has passed into the English language to mean a hugely over-complicated, rickety contraption designed to do a very simple task in the most pointlessly elaborate way. The eponymous William Heath Robinson was a British cartoonist and illustrator, born in London in 1872. He began his career illustrating books in 1897, and his first unlikely machine appeared in his own production, a children's fantasy, *The Adventures of Uncle Lubin* (1902). A more recognizably Heath Robinson contraption made its appearance in 1908 in the 'Great British Industries' series. His work now attracted national attention and he established his reputation as a humourist working for publications such as *The Sketch*. Although his early style tended towards the grotesque and even macabre, ironically, by the time war broke out in 1914 he had moved towards the whimsical and ridiculous. Where some cartoonists reacted with vicious and racist attacks on German culture and character, Heath Robinson continued to use the absurd. The humour is gentle and mocking, and Germans and British appear equally ridiculous in these wartime cartoons.

The present publication brings together three of Heath Robinson's wartime works: *Some 'Frightful' War Pictures* (1915), *Hunlikely!* (1916) and *The Saintly Hun: a book of German virtues* (1917). In these works we see the fully-fledged Heath Robinson style, with a huge array of imaginative and ridiculous military contraptions being employed for a decidedly non-deadly war effort. There are allusions to the atrocity stories that were being employed elsewhere to denigrate the Germans and encourage patriotic sentiment, but here the references are oblique and do not attempt to address any specific issues. Flouting of the Hague Convention, for example, might involve only the use of a fiendish magnetic device to remove the buttons from Tommies' uniforms, or blasting the British trenches with a cold draft to give the soldiers stiff necks. A German gas attack utilizes laughing gas to render the British helpless, the Germans being depicted advancing across a very friendly no-man's land on silly two-wheeled trolleys, each man squirting the gas from a siphon attached by pipelines to an absurdly large gas holder. Guns, bombs, shells, bayonets, barbed-wire, trenches, aeroplanes – all the horrible paraphernalia of war – are depicted in many of the cartoons, but they are rendered harmless by the absurd uses to which they are put. In *The Saintly Hun* Heath Robinson is at his most drily ironic. The cartoons are less concerned with machines, and more with a reversal of the usual depiction of the German

character. Here, there is nothing the German officer or soldier will not do to avoid harming a living thing, be it a child, old lady or a mangy cat. The irony is of course in the marked contrast this represents with the lurid reports then circulating in the newspapers. Although in his gentle way Heath Robinson was drawing attention to these stories, there is no rancour or hate in his depictions, and perhaps one can detect too an undercurrent of mockery of not only German propaganda, but also more hysterical sections of the British Press.

If the hope was simply to amuse the soldiers, it appears to have worked. These cartoons were immensely popular, and one Royal Flying Corps Officer even noted in his diary that he dropped copies of *Hunlikely!* on the German trenches as part of the preparation for the Somme Offensive.

Heath Robinson continued to work as a cartoonist and illustrator after the war, and was called upon once again in the Second World War to entertain a country in the midst of conflict. He died of heart failure in 1944, aged 72. The absurd caricatures and stereotypes in Heath Robinson's cartoons are very much of their time, but they are devoid of bitterness or anger, and for this reason their humour remains fresh, and we can still laugh at them today.

Mike Webb
Bodleian Library

INTRODUCTION

William Heath Robinson, now known chiefly for his drawings of comically over-elaborate contraptions, was a brilliant artist whose ambition initially was to be a landscape painter. However, he soon discovered that his landscapes would not earn him a living. He worked first as an illustrator and by the early 1900s was acknowledged as one of the leading practitioners of the age. A publisher's failure to pay him for a major project led him to try his hand at humorous art and he was soon being fêted as a unique talent in this field too. His subjects were human nature and particularly those individuals who had an inflated view of their own importance. He quickly discovered that this could be demonstrated through over-complicated machinery, and so were born the 'Heath Robinson' gadgets and contraptions for which he was to become famous.

Heath Robinson was born on 31 May 1872 in North London, the third son in a family of four boys and two girls. He left school at fifteen to begin his training as an artist, first at Islington school of art and then at the Royal Academy Schools. On leaving art school he painted landscapes on Hampstead Heath for six months but when he exhibited his work only one sold and that to a friend of his mother. He had no private income, so had to find a surer way of paying the bills. His two older brothers were already making money from illustrations for books and magazines and so he joined them. He quickly established himself with London publishers, being dubbed a 'worthy disciple of the modern school of penmen'[1] by *The Studio* magazine in 1900.

In 1902 Heath Robinson approached the publisher Grant Richards with a children's book that he had both written and illustrated called *The Adventures of Uncle Lubin*. Richards was enthusiastic about the book and by September it was in print ready for the Christmas market. It was a remarkable production, designed from cover to cover by the artist and visually stunning throughout. Following the success of *Uncle Lubin*, Heath Robinson was set to work to illustrate a large and finely printed edition of *The Works of Rabelais* with 100 full-page drawings and over 150 headpieces and vignettes. Writing to the US publisher J.P. Lippincott seeking a co-publication deal, Richards said that:

> . . . my own interest in the production is limited to my admiration for Mr Heath Robinson's work and my anxiety to give him this chance of producing what I think will be a really fine monument, for I never could read Rabelais and I don't suppose I ever shall be able to. [2]

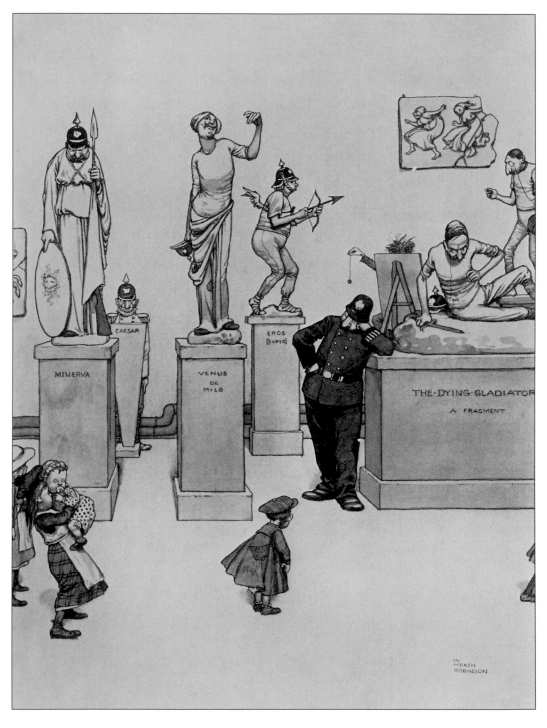

GERMAN SPIES IN THE GRÆCO-ROMAN GALLERIES OF THE BRITISH MUSEUM

The Sketch, 1 June 1910

Sadly no deal was forthcoming and the cost of publishing the book contributed to the failure of the firm of Grant Richards. Heath Robinson had received a small advance, but was left without payment. He was recently married with a young child and so he turned to the up-market weekly magazines that were always in need of humorous drawings and paid in cash on delivery. Thus began a second career, that of humorous artist, which he conducted in parallel with his activities as an illustrator.

He showed his drawings to a number of publishers with little success, one commenting '… if this work is humorous, your serious work must be very serious indeed'. Eventually he sold enough drawings to *The Tatler* to tide him over – mostly parodies of Symbolist paintings by artists such as G. F. Watts. His breakthrough as a humorous artist came with a series of drawings collectively titled 'The Gentle Art of Catching Things' which were published in *The Sketch* in 1906. They depicted such activities as 'Spearing wild moths in the Canaries' or 'Clubbing whitebait at Greenwich'. The following year an article in *The Lady's Realm* magazine praised his work and declared that he was 'so original that he can be compared … only with himself'.[3]

The mechanical element first entered his work with the series 'Great British Industries – Duly Protected' which was published in *The Sketch* from December 1908. For the next few years he worked in parallel as illustrator and humourist, but with the onset of the First World War the market for finely illustrated books rapidly diminished, a trend hastened by increasing paper shortages. Conversely, the demand for humorous work greatly increased. Unlike many of his fellow artists Heath Robinson used gentle satire and absurdity to counter both the pompous German propaganda and the fear and depression engendered by the horrors of war. What better antidote to these horrific stories than a Heath Robinson drawing of 'The Hun' using not mustard gas, but laughing gas, to disable British troops.

He had started to satirize the enemy as early as 1910. Public anxiety about a German invasion had been prompted by William le Queux's novel *The Invasion of 1910*, published in 1906 and serialized in *The Daily Mail*, but it was Guy Du Maurier's invasion-scare play *An Englishman's Home* that generated an extraordinary level of media interest. Heath Robinson parodied this in a series of six drawings under the title 'Am Tag! Die Deutsche Kommen (Very)!' that appeared in *The Sketch* between April and June 1910. They were followed by five more drawings in the next issue of the magazine showing 'The Day: the Germans Come – and are 'Terror'-ised' (by the British Territorial Army).

When war was declared in August 1914, Heath Robinson was hard at work completing the illustrations for a new edition of *A Midsummer Night's Dream*, arguably the finest of all of his illustrated books, which was published by Constable for Christmas 1914. He had been regularly contributing humorous drawings to *The Sketch* since 1906 and was naturally called upon to address the all-absorbing topic of the day. Between October 1914 and January 1915 a series of nine of his drawings on war subjects were published under the general heading of 'Kultur'. These depicted such devices as the British 'Drilling Frame for Raw Recruits' and the German 'Reconnoitring Mortar'. A further six war drawings appeared in *The Sketch* during the first half of

1915 and his work was also published in *The Illustrated Sporting and Dramatic News,* an even larger and more upmarket magazine. Then, in June 1915 came the first of a series of twelve drawings depicting 'German Breaches of the Hague Convention' as seen through Heath Robinson's eyes. This showed the Germans attempting to attack the Tommies with scalding kettles or making them cry by whittling onions under cover at night.

These pictures proved immensely popular with both servicemen and with the public and he was inundated with letters thanking him for bringing humour into otherwise grim lives, asking for copies of his work and frequently offering suggestions for future drawings. Very few of these ideas had any potential for development, but one from the officers of the 87th Royal Irish Fusiliers in Flanders was quickly translated into print. Their letter dated 21 March 1915 offered the following suggestion:

> The scene is the battle front in Flanders where the opposing trenches are only twenty & thirty yards from each other. A sporting British officer has got a large fishing rod & some strong line & is casting for souvenirs in the shape of German helmets which can be seen popping up and down behind the German parapet. The picture might be entitled 'The new war game – Picking the Pickelhaube' (an example of English frightfulness).[4]

Heath Robinson's interpretation was published in *The Illustrated Sporting and Dramatic News* on 8 May 1915 with a note acknowledging '… the suggestion of officers at the front on which this new "War Sport" was based'.

The popularity of the pictures resulted in the publication for Christmas 1915 of a collection of the best of them in a volume titled *Some Frightful War Pictures.* The book comprised twenty-one images from *The Sketch* and three from *The Illustrated Sporting and Dramatic News* and these were supplemented by humorous silhouettes specially drawn for the book. The first edition was finely printed in a large format and bound in hard covers with pictorial endpapers. Unfortunately, wartime restrictions meant that reprints were produced on poor paper and with paper covers, losing the exciting binding and endpaper designs.

Heath Robinson's drawings continued to be published in *The Sketch* with what was perhaps his most popular series, 'Inventions rejected by the Inventions Board', appearing between August 1915 and February 1916. The ten pictures include 'The Water Bottle Rotary for Warming Scots Legs', 'The Armoured Corn-Crusher for Treading on the Enemy's Toes' and 'The Pilsner Pump for Tapping the Enemy's Supper Beer'. His work was also appearing in more modest publications such as *The Strand* and *Pearson's* magazines and *London Opinion.* In 1915 *The Strand* published an excellent series, 'The Fine Art of Making a War Film'. Another series, 'When Peace Comes Along', showing how war surplus equipment might be employed in civilian life, followed in 1917.

A second collection of wartime cartoons was published by Duckworth in 1916 under the title *Hunlikely.* This drew material from *The Sketch, The Illustrated Sporting and Dramatic News, The Strand, Pearson's* and *London Opinion.* It was again finely printed and bound in hard covers with

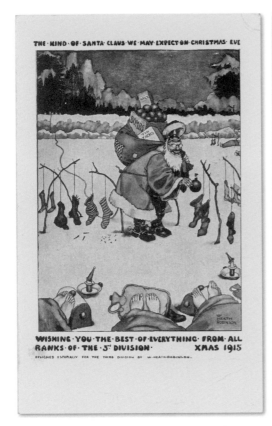
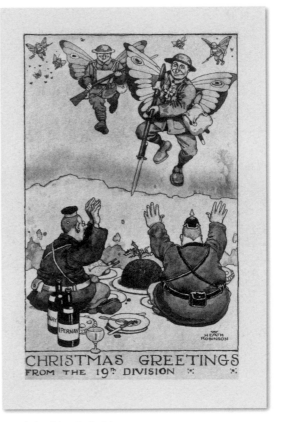

War-time Christmas cards by Heath Robinson

pictorial endpapers, but with a smaller page size. As before Heath Robinson made a number of humorous silhouettes to complement the full-page illustrations.

In May 1916 the magazine *T.P.'s Weekly*, edited by the MP T.P. O'Connor, was relaunched as *To-day*. To help build circulation Heath Robinson was commissioned to make a new series of war pictures and the subject that he chose was 'The Hun Virtuous'. In these drawings he is at his most drily ironic. There were fifteen drawings in the series and all but one of them were reproduced in the third collection published by Duckworth, which was retitled *The Saintly Hun*. Again, Heath Robinson added a number of small humorous silhouettes, but this time to make up the required forty-eight pages he also added eight glorious double-page scenes in silhouette depicting such events as 'The Kaiser laying the foundation stone of a new prison to be devoted exclusively to the lower orders' or 'The very first Hun resisting temptation' (a parody of the Garden of Eden). It was published in 1917 in paper wrappers with a blue and orange label pasted on the front showing a stained glass window depicting an angelic Hun.

On 24 January 1917 a new magazine was launched and again Heath Robinson was recruited to help boost its circulation. Its title was *Flying* and its eponymous subject offered Heath Robinson

endless scope for the kind of drawings for which he was now becoming best known. His home in Pinner was close to the Royal Flying Corps base at Ruislip, so he would have had plenty of opportunity to observe military aircraft in flight. These drawings were collected in another Duckworth book called *Flypapers*, but given that only about half the thirty-eight drawings published in *Flying* were directly associated with the war, it is not reprinted in this volume.

Heath Robinson received many requests to contribute to the magazines produced by individual formations or units or to charity publications and he responded generously with specially made drawings. Among those that include such work are *The Dump* (XXIII Div, BEF, Christmas 1916), *Sparklets* (the Royal Engineers magazine, 1916), *The Sphinx* (Manchester Regiment, 1916), *The Machine Corps Magazine* (1917), *Sea Pie* (1917) and *Canada in Khaki* (Nos. 1 & 2, 1917). He also received requests for Christmas card designs for individual divisions or units. The first of these, for the 3rd Division, is in a simple post card format and shows 'The kind of Santa Claus we may expect on Christmas Eve'. More elaborate was the card made for the 12th Battalion, The Sherwood Foresters in 1917. This was printed in sepia on parchment-like paper in landscape format and comprised a cover design, two pages of verse and a drawing of Father Christmas arriving in the trenches. A third card was made in 1918 for the 19th (Western) Division and was printed by photogravure in traditional folded format. Its surreal design featured a small vignette of a British Tommy with butterfly wings on his back carrying a large Christmas pudding on the front. Inside was a full-page picture showing more British soldiers with butterfly wings descending through the air to surprise a pair of stout German soldiers who are eating their Christmas dinner. The British soldiers are grinning, while the Germans throw up their hands in surrender. The divisional symbol of the 19th Division was a peacock butterfly.

Heath Robinson's popularity during his lifetime resulted mainly from his brilliant and unique humorous work. He was an unusually prolific and versatile artist with a seemingly never-ending stock of good ideas. But the secret of his appeal, like artists such as Hogarth and Rowlandson before him, lay in his genuine abilities as a serious artist.

As a man, he was shy, modest and gentle and enjoyed family life. Approached by a journalist who was putting together a symposium article, he was asked what his hobbies were. The answer was that he didn't have any — what spare time he had he spent painting. Another request came from a journalist asking what was his favourite quotation. The answer was 'They all lived happily ever after'.

Geoffrey Beare
The William Heath Robinson Trust

1 *The Studio*, December 1900, Vol XXI, p209.
2 Grant Richards Archive, University of Illinois Library.
3 'The Delicacy of Humour' by M.H. Dixon. *The Lady's Realm*, Dec. 1907, Vol 23, pp. 231–8.
4 The William Heath Robinson Trust collection.

SOME 'FRIGHTFUL' WAR PICTURES

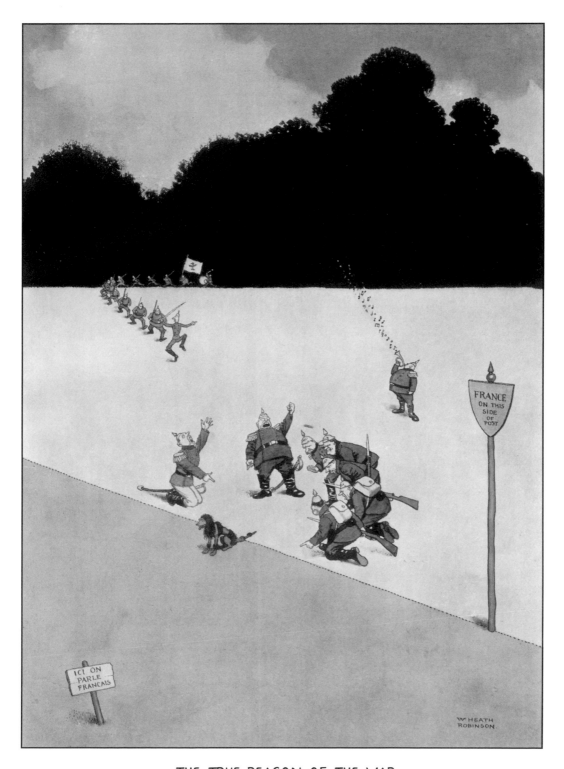

THE TRUE REASON OF THE WAR
A little Frontier Incident in Alsace. July 1914

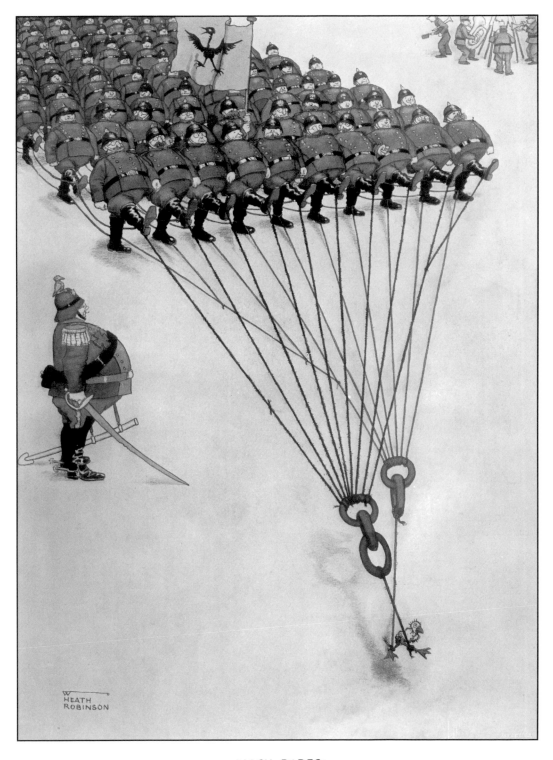

NACH PARIS!
First Lessons in the Goose-step

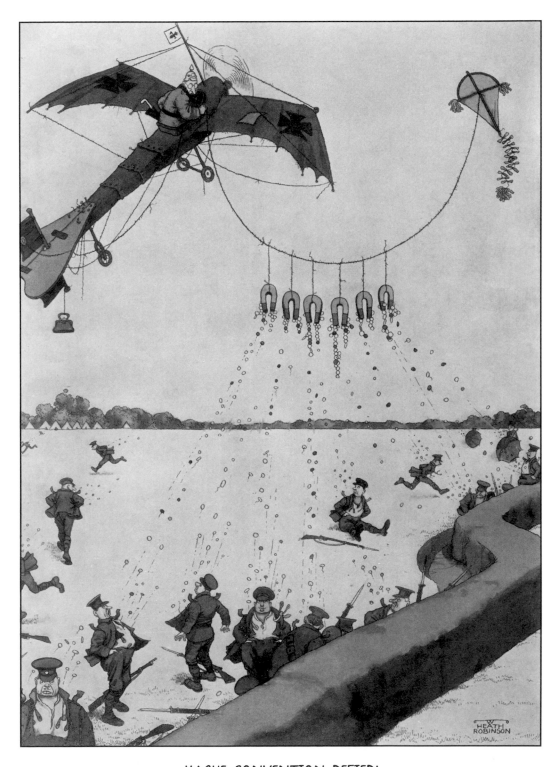

HAGUE CONVENTION DEFIED!
The Germans use Button Magnets

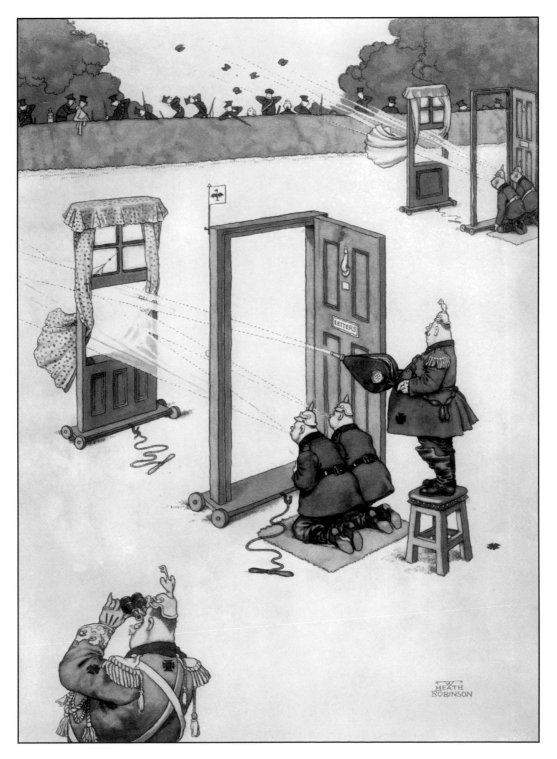

HAGUE CONVENTION DEFIED!
Stiffnecking Tommies by directing Draughts on the British Trenches

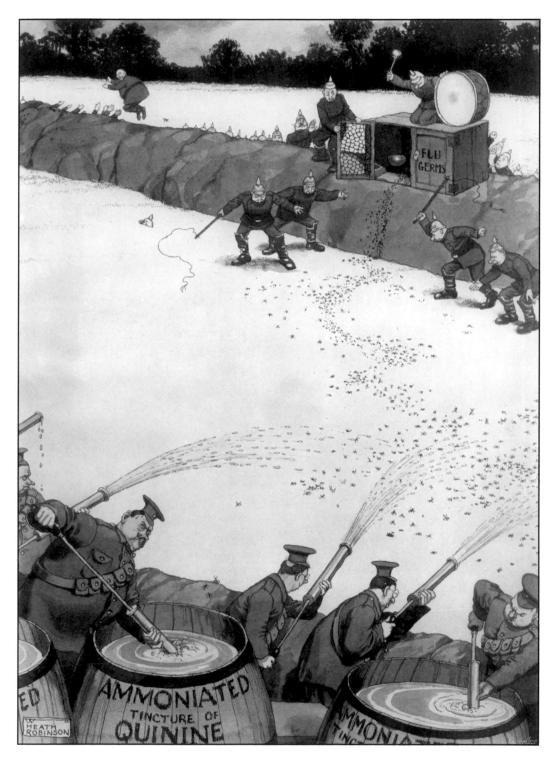

HAGUE CONVENTION DEFIED!
Repelling an Assault of 'Flu Germs

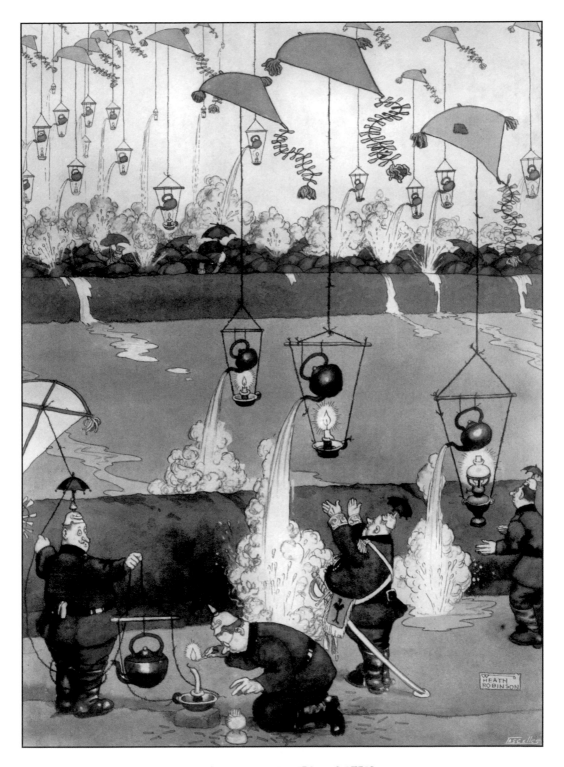

HAGUE CONVENTION DEFIED!
Failure of the new Tommy-scalder

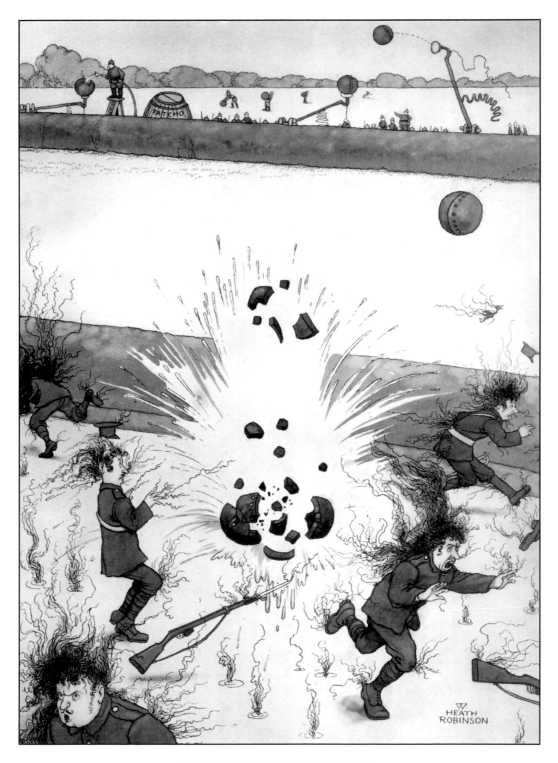

HAGUE CONVENTION DEFIED!
The Tatcho Bomb

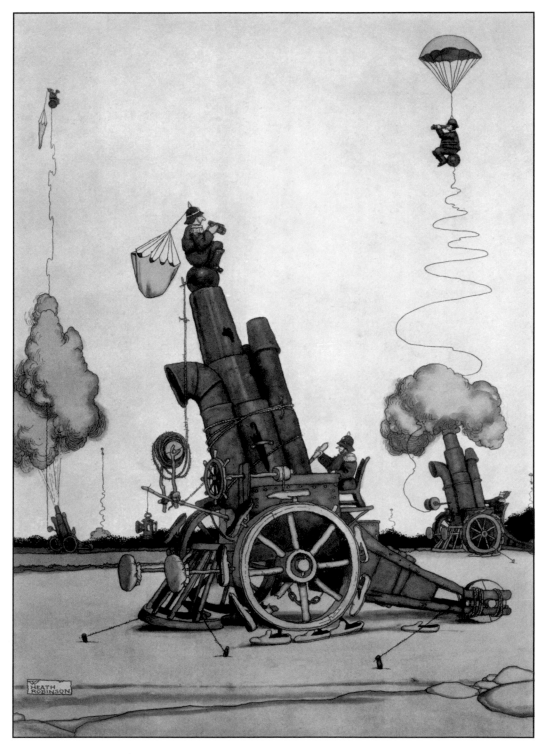

KOLOSSAL!
Krupp's Great Reconnoitring Mortar

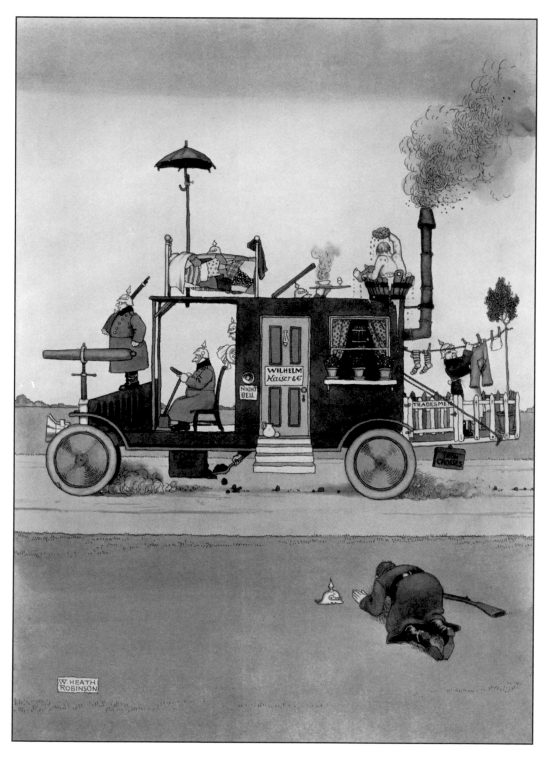

THE WAR LORD AT THE FRONT
A Morning Tub on the Imperial Campaigning Car

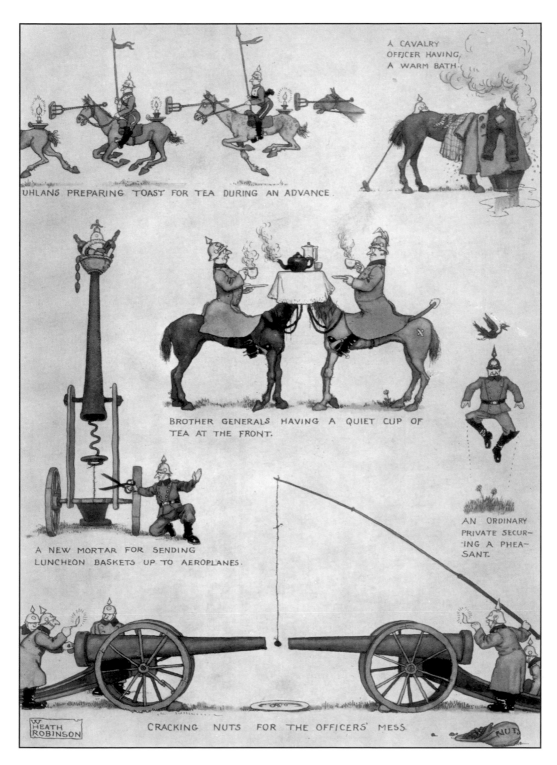

WAR KOMFORTS!
Some Notes in a German Bivouac

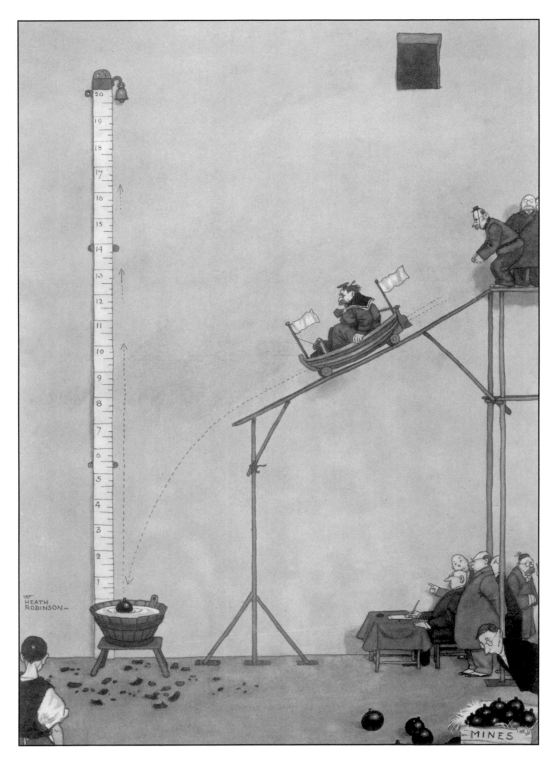

MUNITIONS!
Testing Mines at Cuxhaven

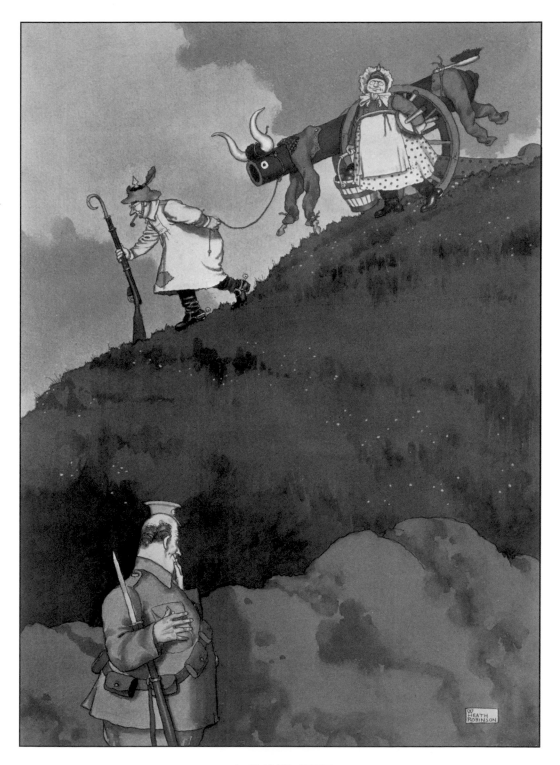

A CLEVER RUSE
How two German Officers carried a Gun past the British Lines

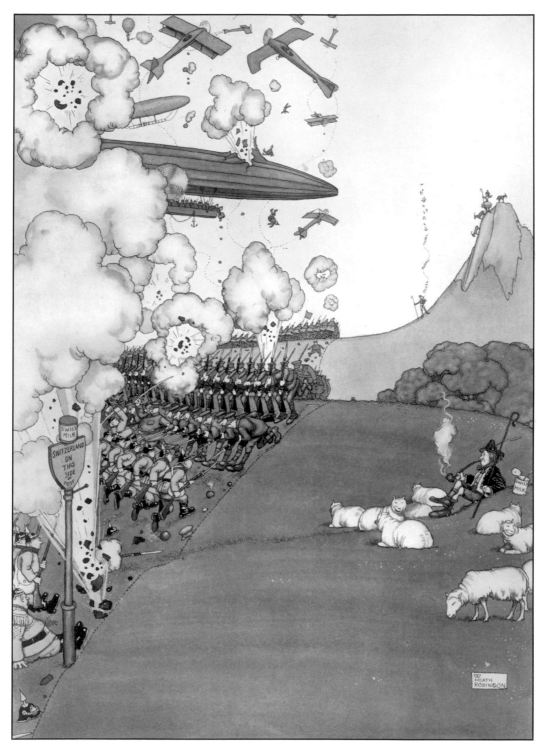

NEUTRAL!
A Swiss Shepherd watching a Battle on the Frontier

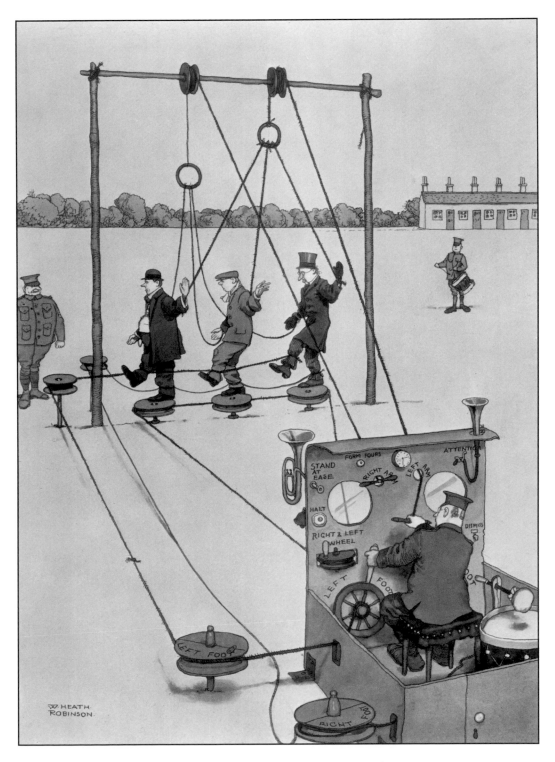

BRITISH PATENT (applied for)
The Drilling Frame for Raw Recruits

Crossing the Yser

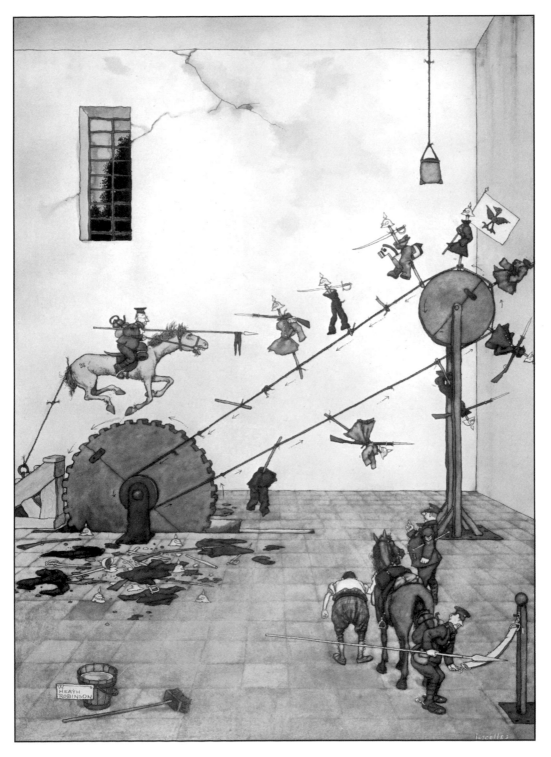

BRITISH PATENT (applied for)
The Lancing Wheel for teaching young Lancers to lance

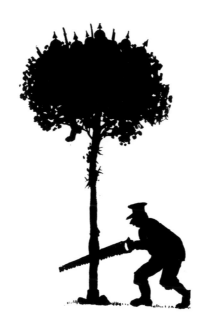

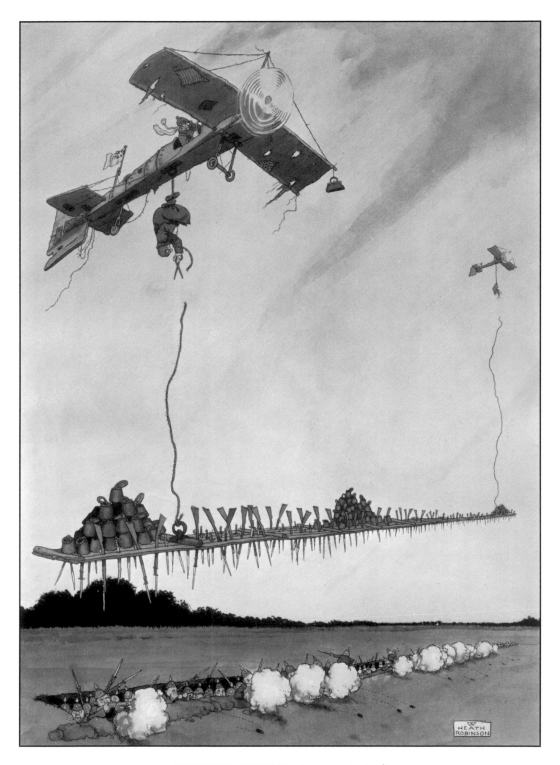

BRITISH PATENT (applied for)
The Trench Presser or Bosch Bayoneter

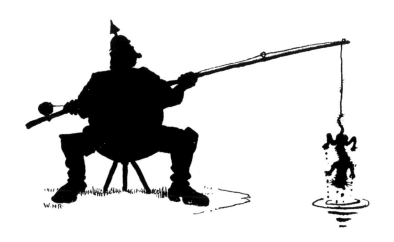

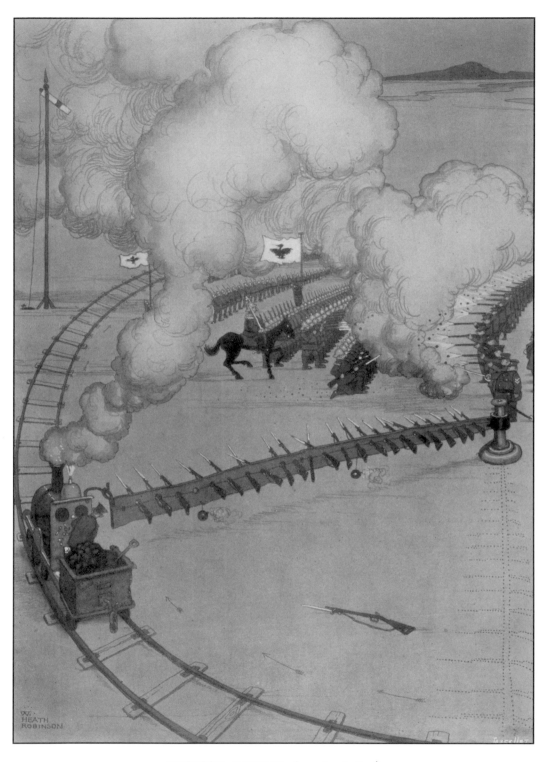

BRITISH PATENT (applied for)
The Outflanking Machine for Turning Movements

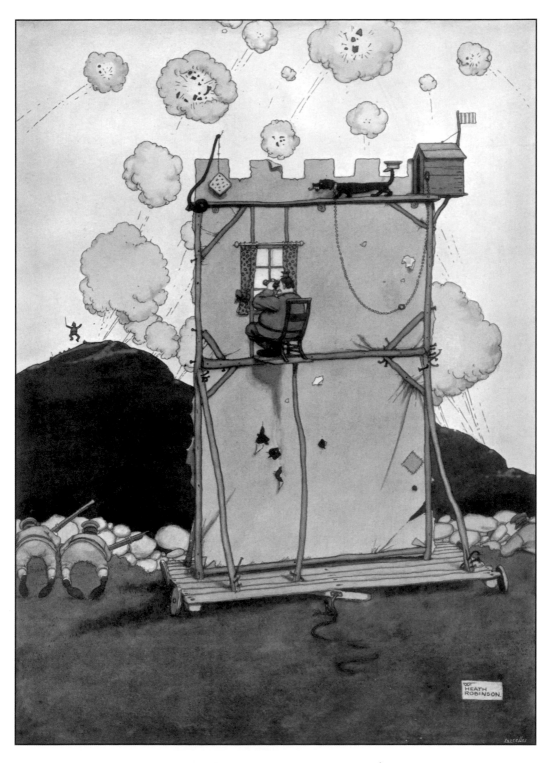

BRITISH PATENT (applied for)
A trained Dog of War drawing the Enemy's Fire

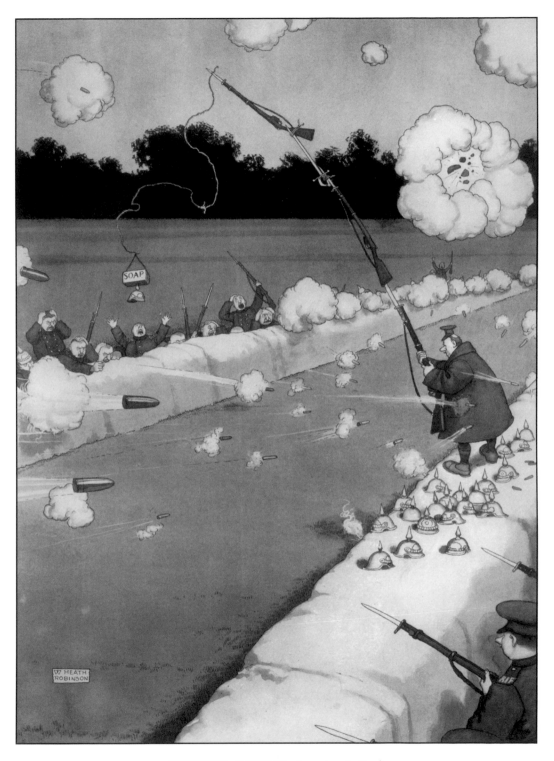

BRITISH PATENT (applied for)
Picking the Pickelhaube: a little Game for the Trenches

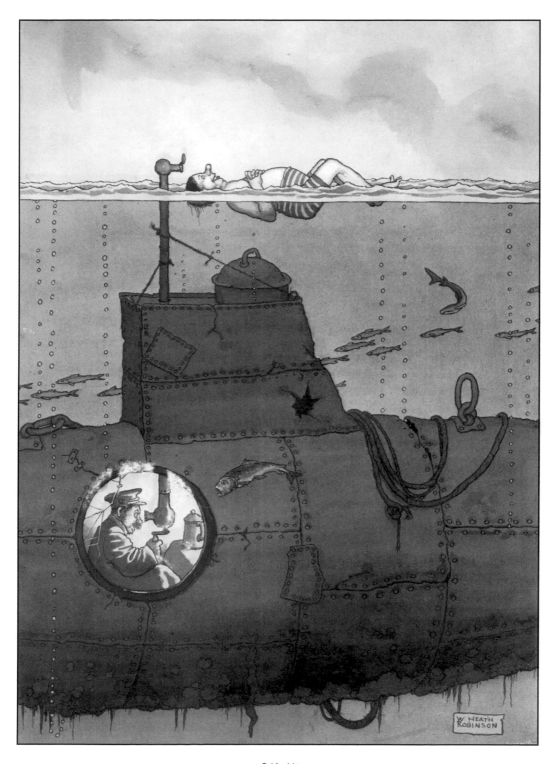

OH U!

The German Periscoper: 'Ach, Himmel! Dot most be der peautiful
Ben Nevis of vich ve 'ave 'eard so mooch!'

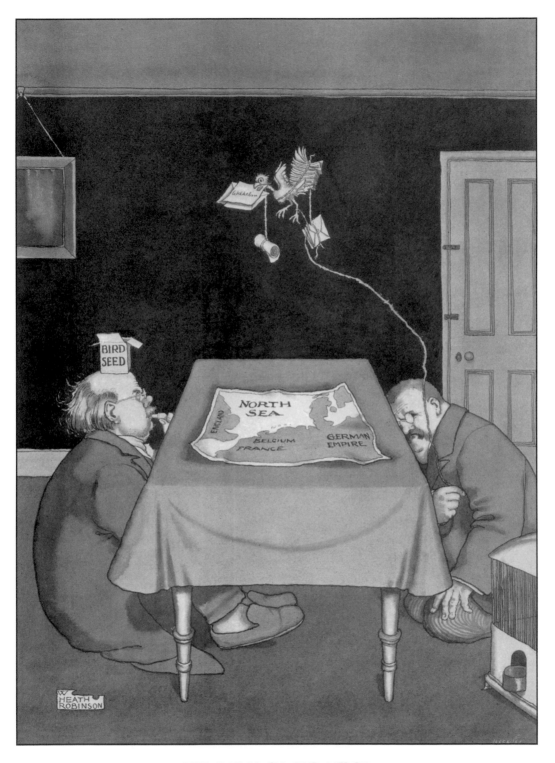

THE ENEMY IN OUR MIDST!
German Spies training a Carrier Pigeon in the Fastnesses of a
London Boarding House

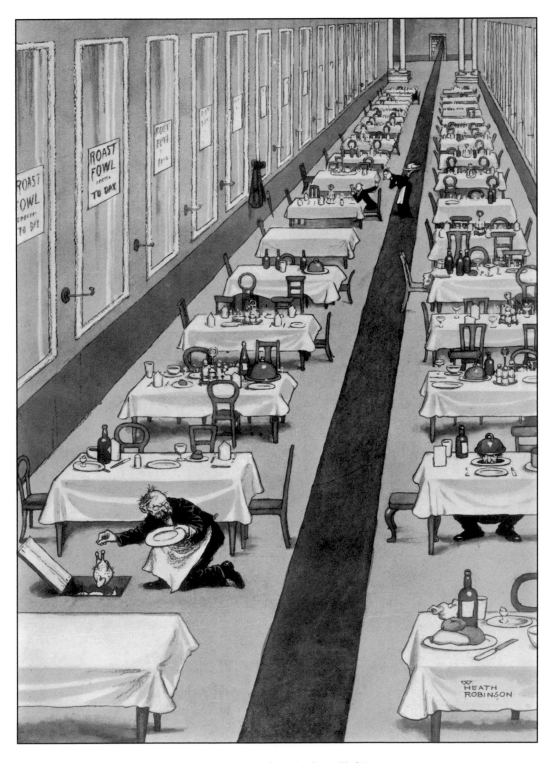

THE ENEMY IN OUR MIDST!
An Extra Special Constable discovering a German Waiter in the Act
of laying the Foundation of a Concrete Gun-bed

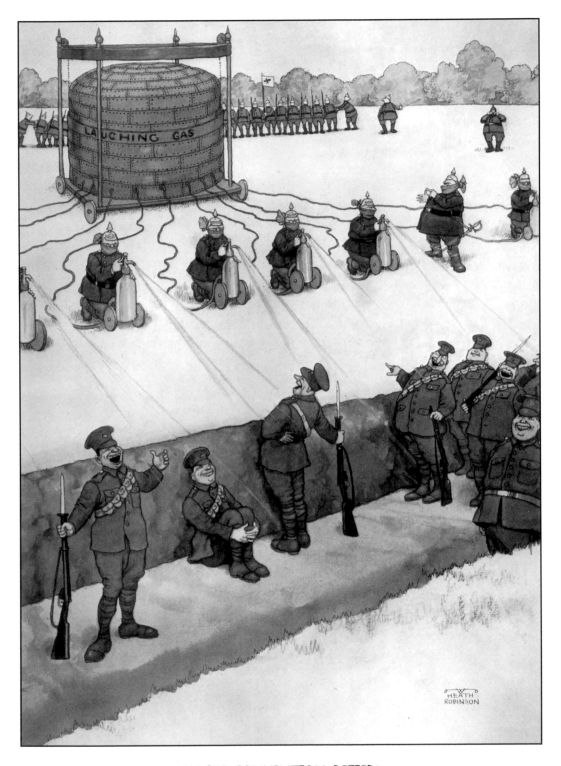

HAGUE CONVENTION DEFIED!
Using Siphons of Laughing Gas to overcome the British before
an Attack in Force

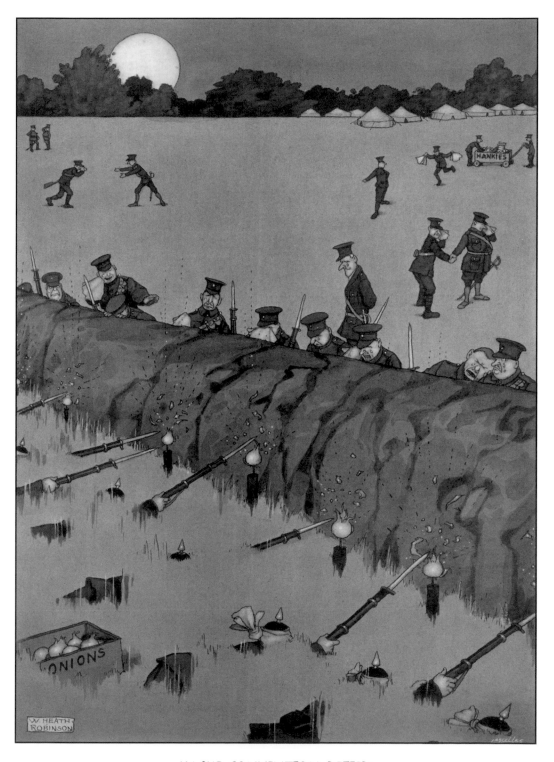

HAGUE CONVENTION DEFIED!
Lachrymosing the British by Onion-whittling under Cover of Night

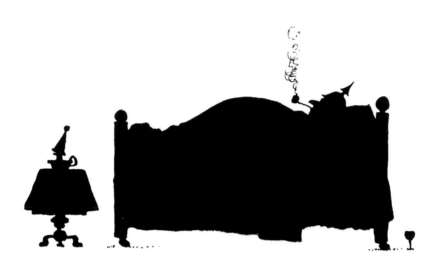

THE END

HUNLIKELY!

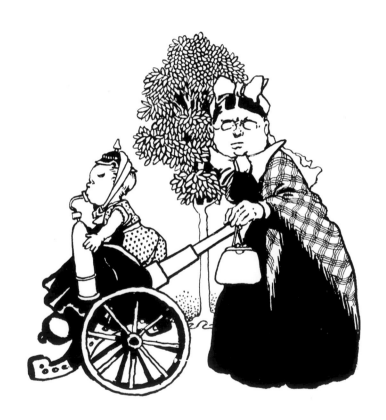

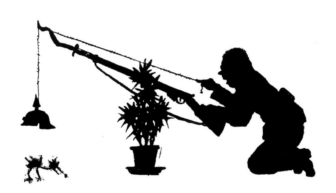

Securing a quail

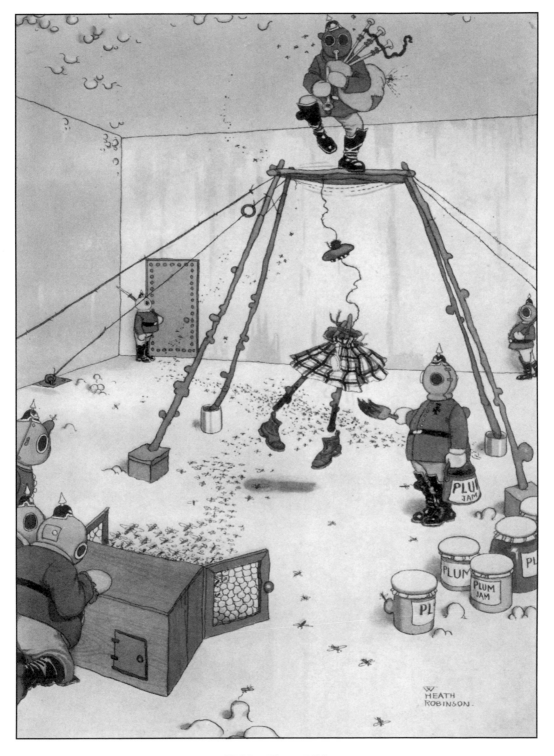

FRIGHTFULNESS!
Germans training Wasps to sting Highlanders in Flanders

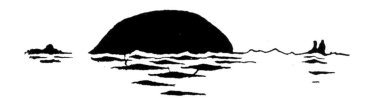

The morning dip, Zeebrugge

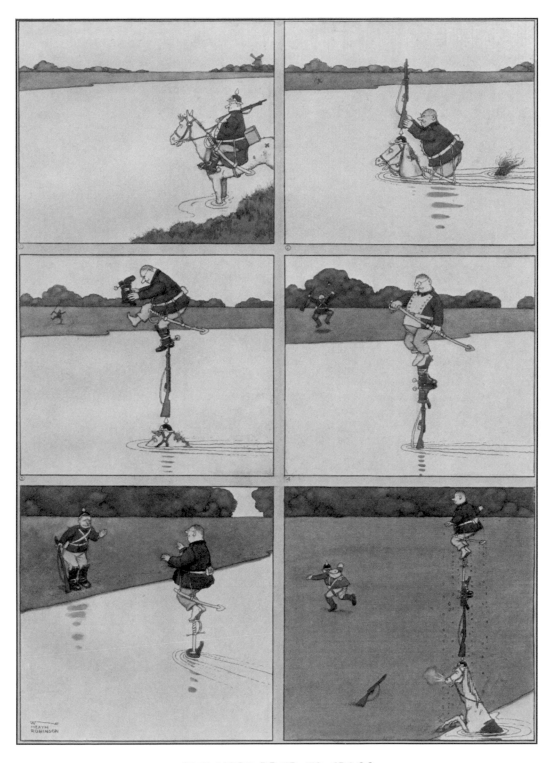

ONE MORE RIVER TO CROSS
How the last German got back across the Yser

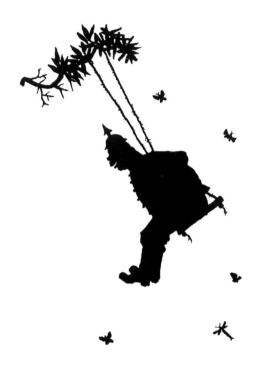

On a half-holiday

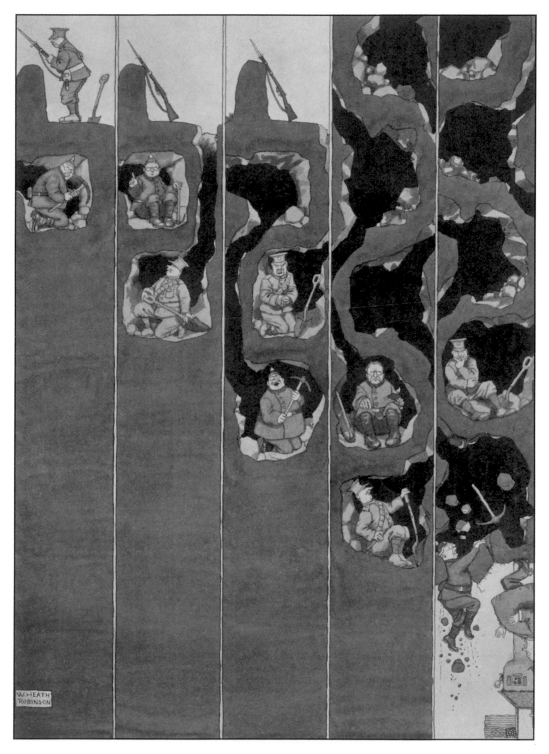

MINE AND COUNTERMINE

Fritz (underground)
'Now, Herr Englander,
mind yourself!'

Tommy (to Fritz):
'Not arf!'

Fritz to Tommy:
'Ha, ha, mein friendt,
he who laughts last–'

Tommy (to Fritz):
'Well, wot abart it?'

After six months of
this sort of thing!

German officer scheming kind actions

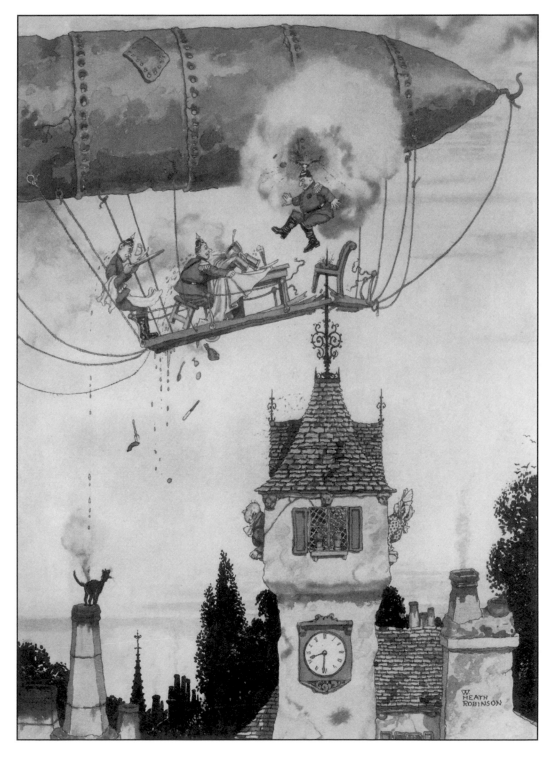

SPIKED!

Unfortunate Mishap to a Zeppelin through a Lack of Proper Caution in Descending

Helping a bird to build its nest

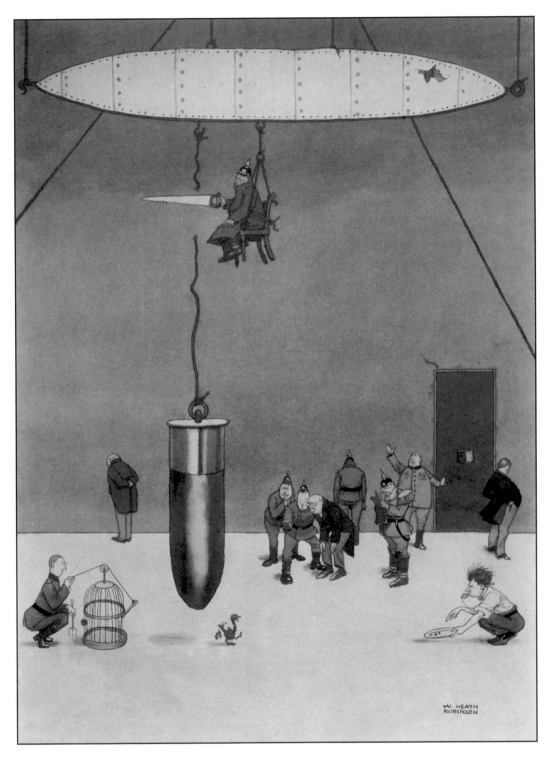

PRACTICE MAKES PERFECT
At Count Zeppelin's Evening Classes for Bomb-droppers

Thoughtful young Prussian entertaining a prisoner

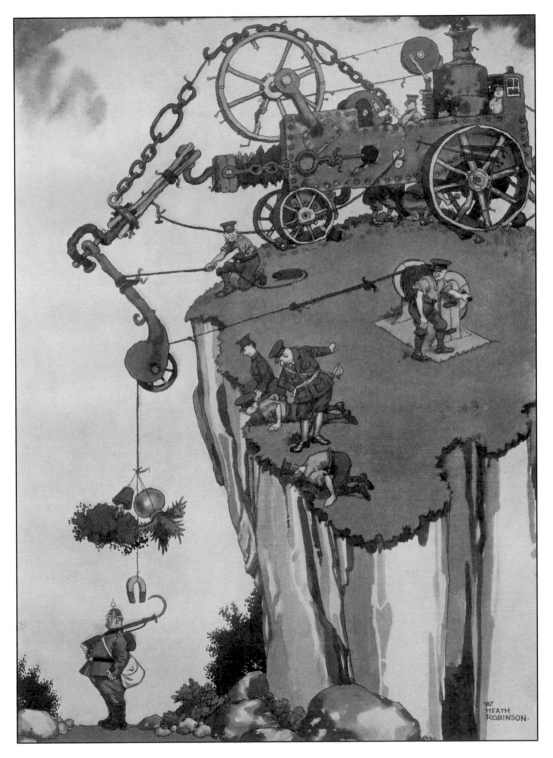

FOR THE WAR INVENTIONS BOARD
The Armoured Bayonet-curler for Spoiling the Temper of the Enemy's Steel

The fortune of war

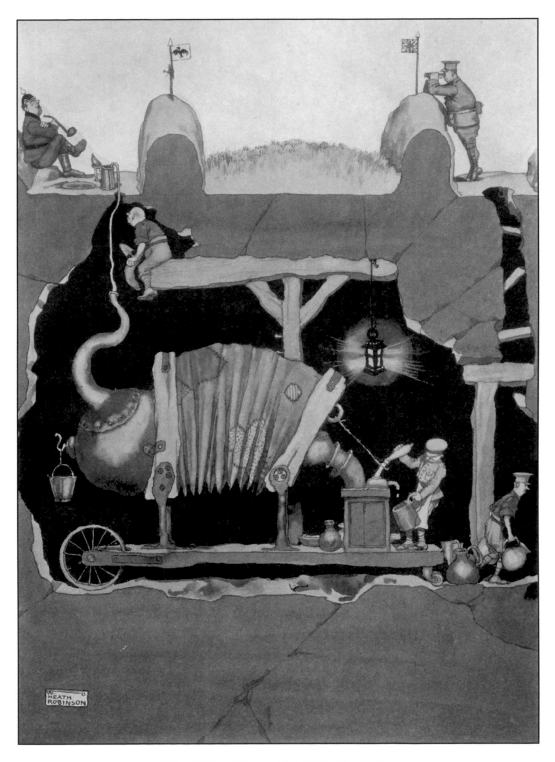

FOR THE WAR INVENTIONS BOARD
The Pilsener Pump for Tapping the Enemy's Supper Beer

Dalliance

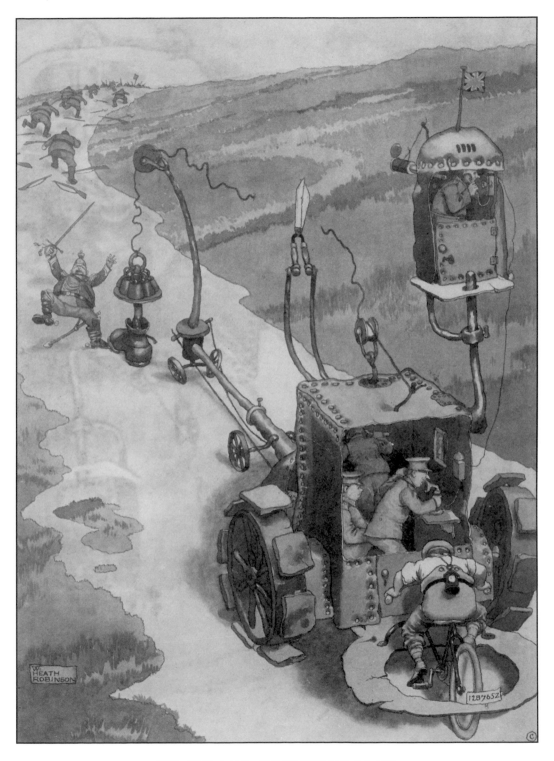

FOR THE WAR INVENTIONS BOARD
The Armoured Corn-presser for Crushing the Enemy's Boot

German love of nature

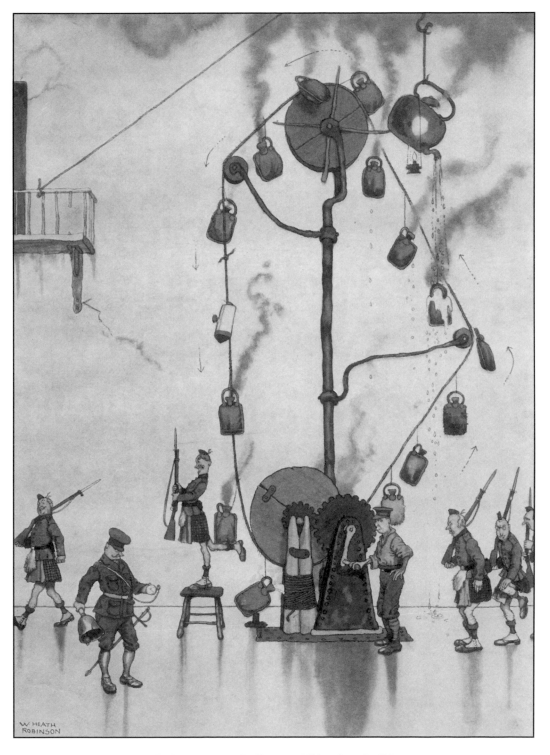

FOR THE WAR INVENTIONS BOARD

The Hot-bottler for Warming Highlanders' Legs after a Night in the Trenches

The captive

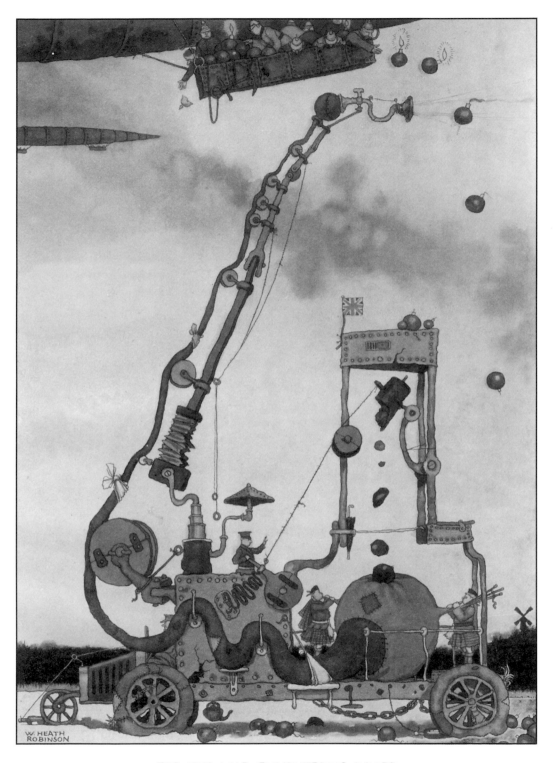

FOR THE WAR INVENTIONS BOARD
The Blow-bomb for Extinguishing the Fuses of Zeppelin Bombs

Modesty of young German officer

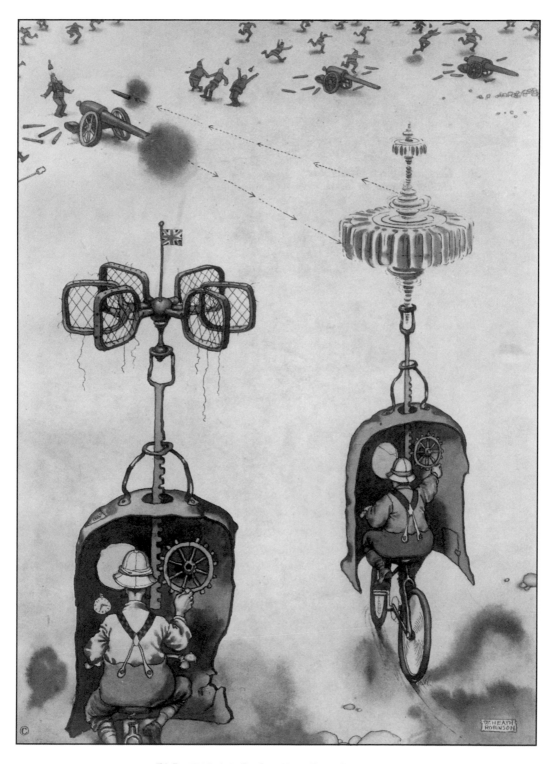

FOR THE WAR INVENTIONS BOARD
The Shell-diverter for Returning the Enemy's Fire

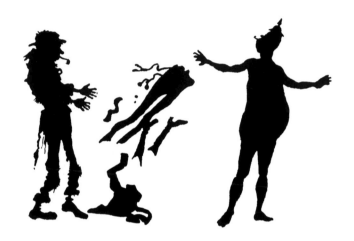

German officer giving his clothes to one in need

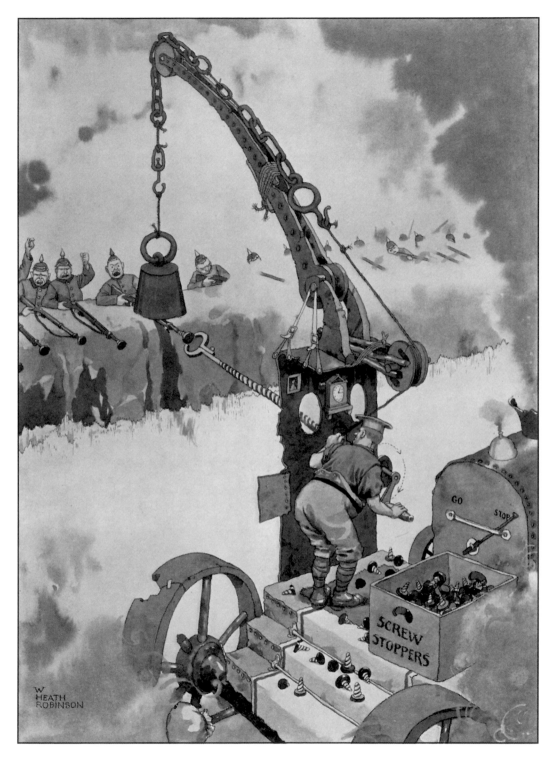

FOR THE WAR INVENTIONS BOARD
The Screw-stopperer for Plugging the Muzzles of the Enemy's Rifles

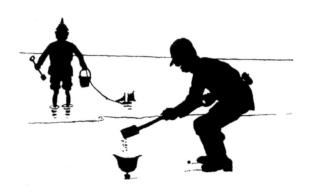

On the sands at Ostend

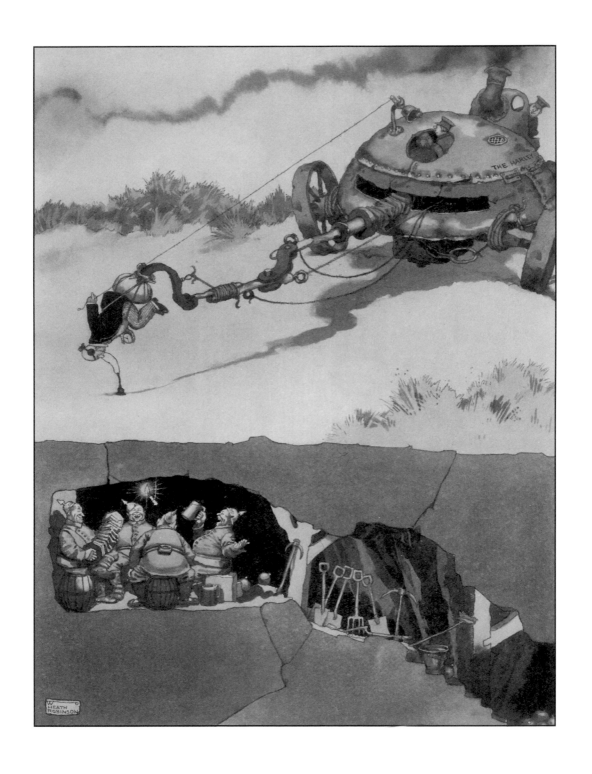

FOR THE WAR INVENTIONS BOARD
The Protected Mine-finder for Use in Sounding for Enemy Mines

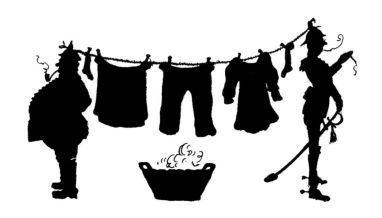

Washing day in the German Army

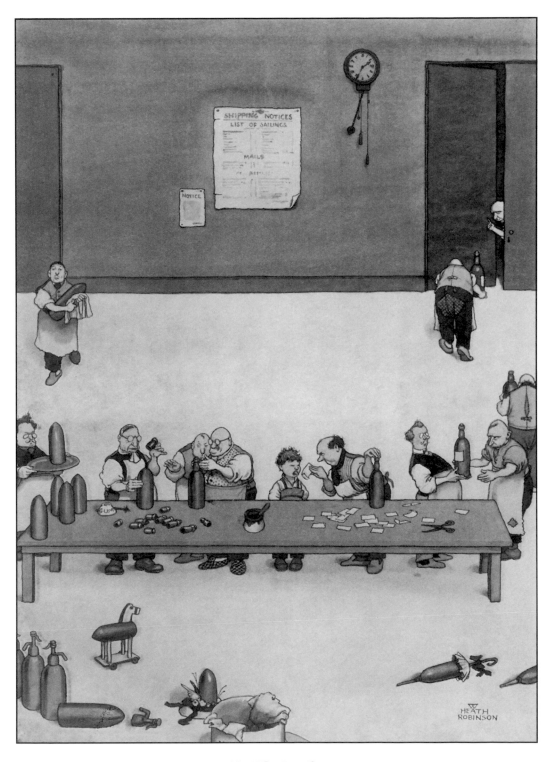

CONTRABAND!
Disguising Shells for Shipment in Neutral Bottles

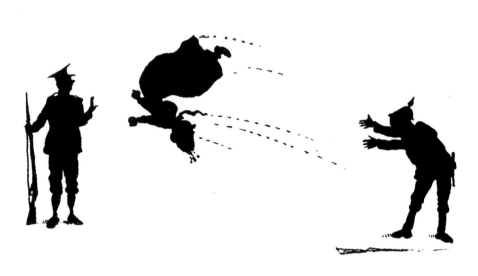

The mother's part

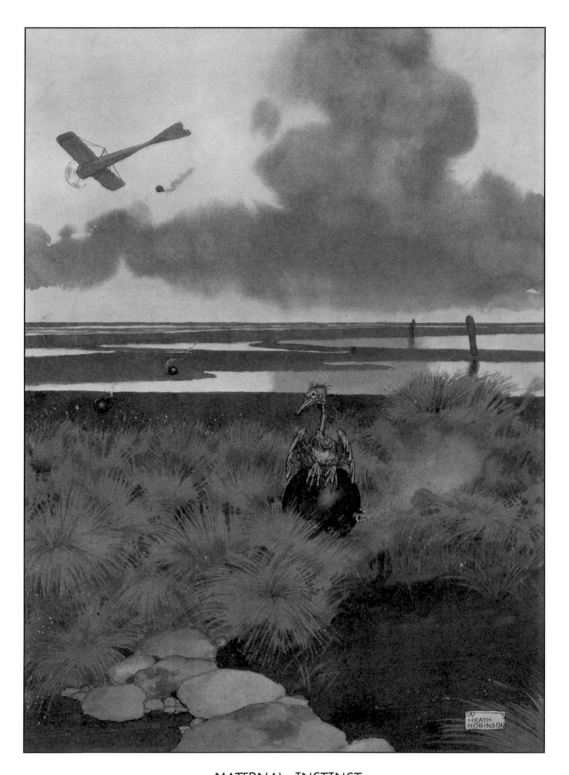

MATERNAL INSTINCT

The Hatcher (soliloquizing): ''Tis an unusual kind of egg, no doubt, but thank
Heaven it is still warm, and I feel the throb of young life within'

Love at first sight

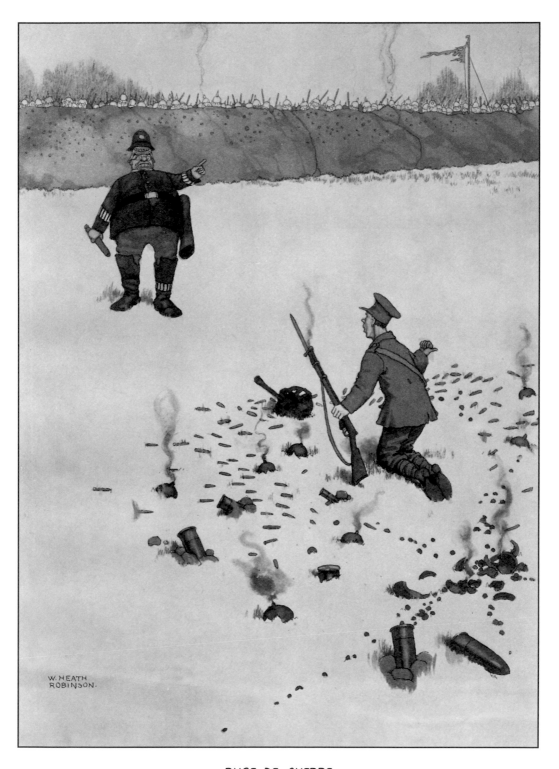

RUSE DE GUERRE

A German Officer disguised as a Policeman endeavouring to move on a
British Sniper

Helping with the washing

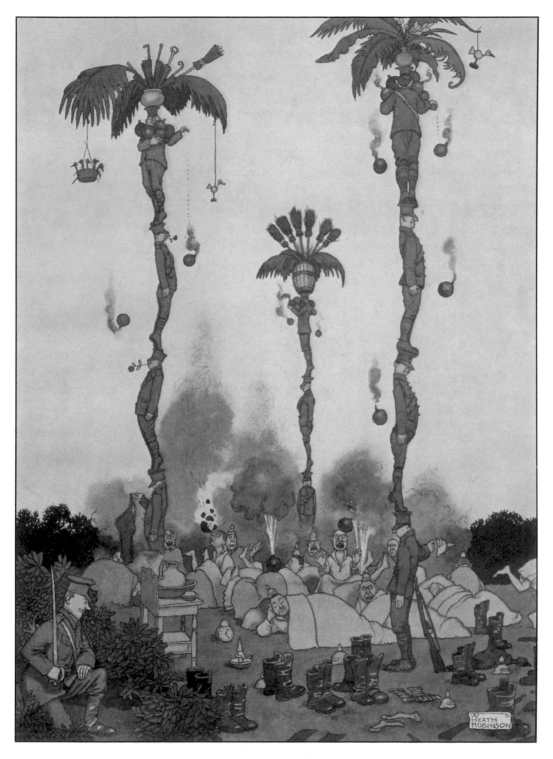

PALMING THEMSELVES OFF!
British Soldiers disguised as a Palm Grove upsetting an Enemy Bivouac

The bit that kept up

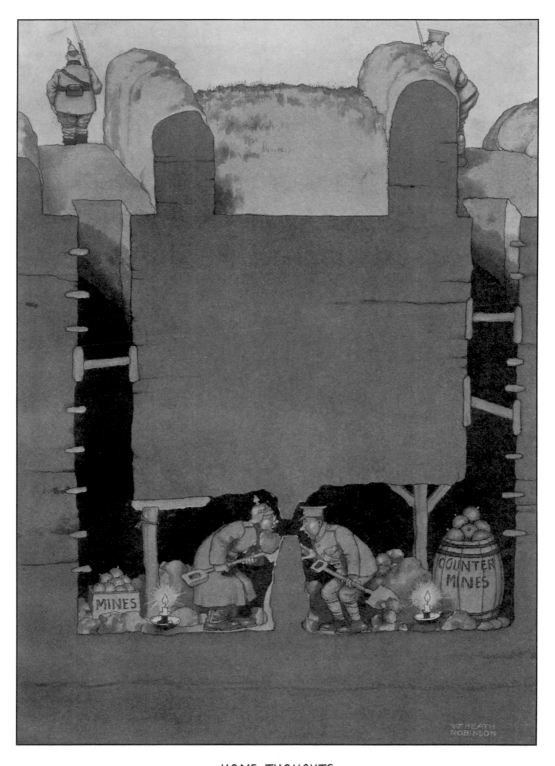

HOME THOUGHTS

Tommy (confused by the sudden encounter): 'Er—er—third return to
'Ammersmith!'

U Boat Commander feeding a starving eel

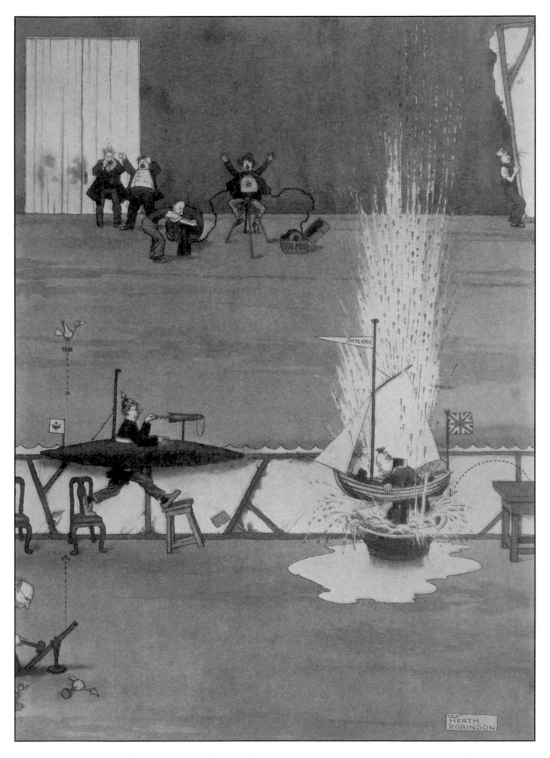

WANGLING WAR FILMS How to make and fake them: I
U Boat sinking a Pleasure Vessel off Brighton

Officer of the Prussian Guard
resisting temptation

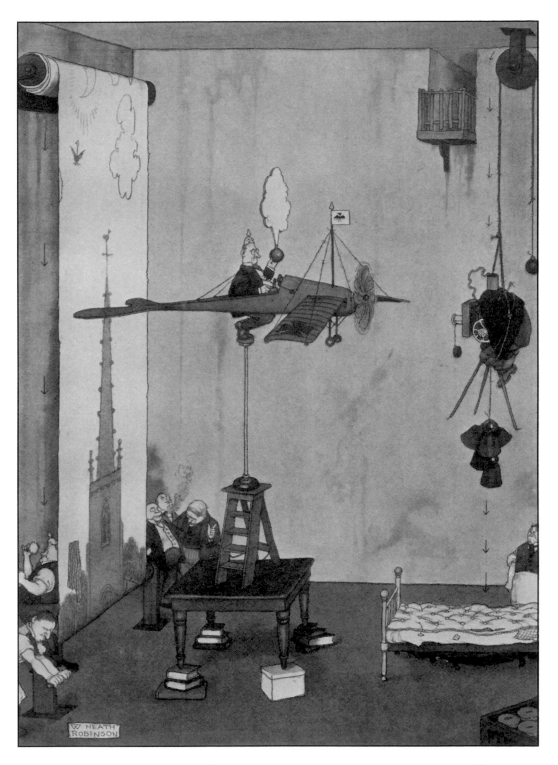

WANGLING WAR FILMS How to make and fake them: II
The Popular Film of a Taube soaring over Rheims Cathedral

The bilious attack

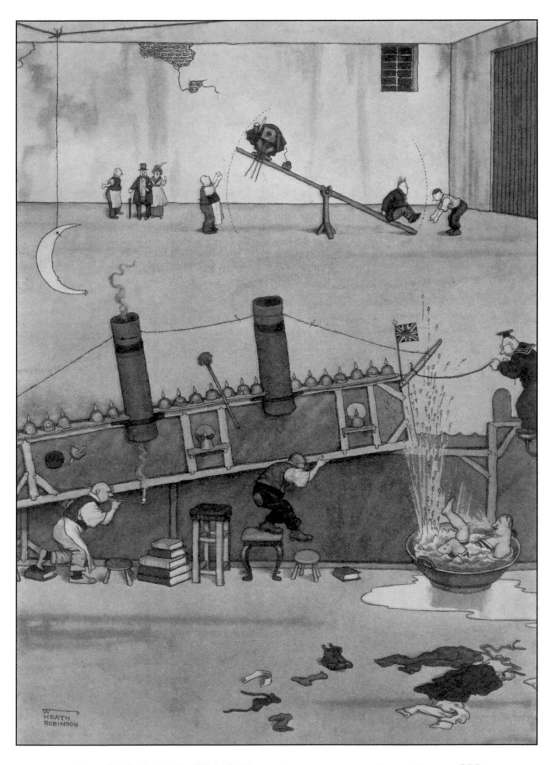

WANGLING WAR FILMS How to make and fake them: III
The Arrival of German Prisoners at Margate Jetty by the Night Boat
from Boulogne

Playfulness of the German

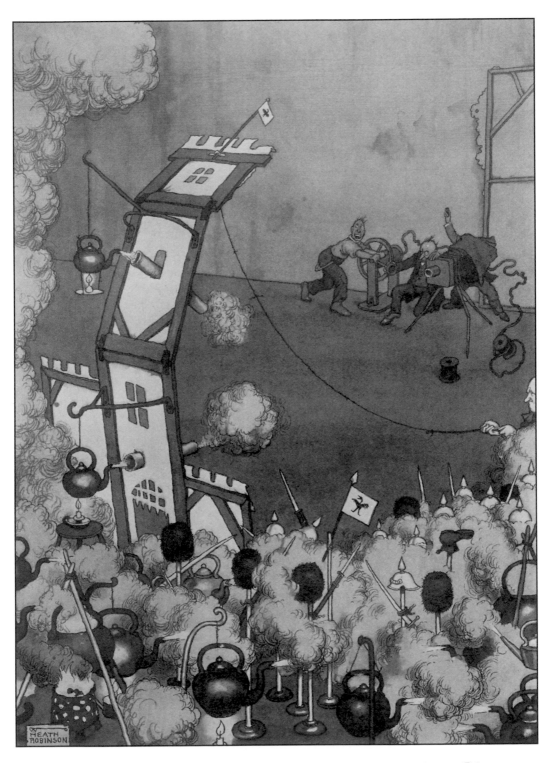

WANGLING WAR FILMS How to make and fake them: IV
The Fall of Przemysl

The beauty of the Goose-step

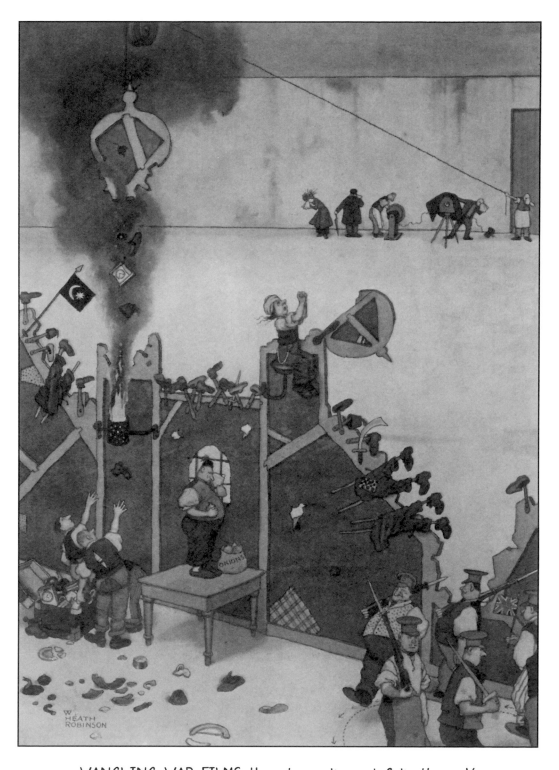

WANGLING WAR FILMS How to make and fake them: V
'The Queen of the Harem' A Pathetic Incident at the taking of
Constantinople

Young Prussian knitting a stocking for his wife

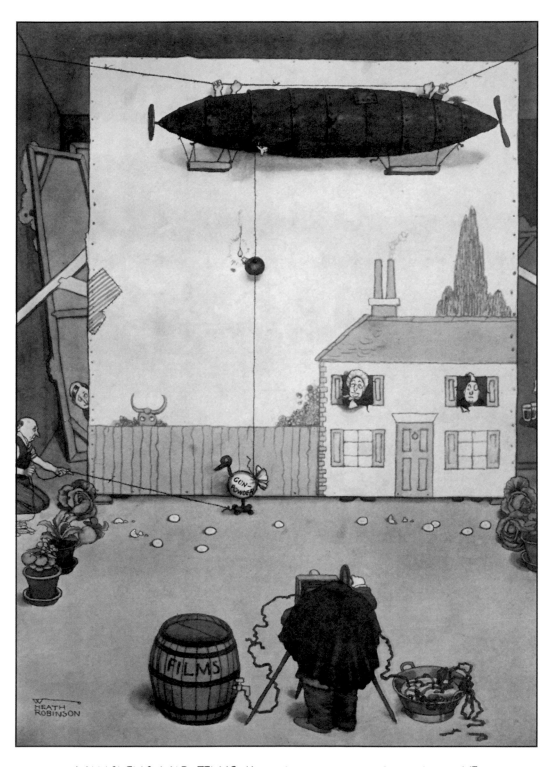

WANGLING WAR FILMS How to make and fake them: VI
A Zeppelin Raid on a Poultry Farm in the Vosges District

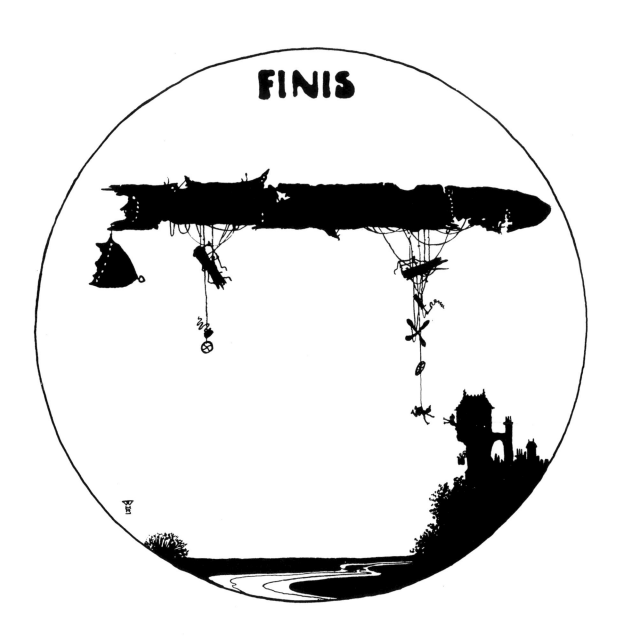

THE SAINTLY HUN

A BOOK OF GERMAN VIRTUES

DEDICATION

To
HIS IMPERIAL HIGHNESS THE
CROWN PRINCE OF PRUSSIA
in appreciation of his greater prowess with
the Loot than with the Sword.

It cannot fail to be apparent that in the course of the last year of so a certain acerbity has insinuated itself into public utterances in this country having reference to our great Teutonic neighbours. It is in the hope not only of checking this lamentable tendency, but in some degree of mitigating the insidious poison which it disseminates, that I have the temerity to place before the British public this collection of drawings.

They embody in the most tangible form which I can achieve the fruits of much observation and study, for which opportunities were afforded me by a series of visits, extending over several years, to that gentle and amiable soul, Herr Krupp of Essen, and that lovable but most whimsical of sovereigns, William of Potsdam.

I have little fear of censure from the fair-minded British public for insisting more particularly, in these drawings, on the virtues of the Teutonic people, rather than on those other characteristics with which the merely superficial observer may have become unduly familiar of late. I am convinced that my fellow-countrymen, to a man, will join me in repudiating the mean schism that virtue is no more than a sickly masquerade. They will rather uphold with me the dictum that virtue is an attribute of surprising charm, without which neither State nor individual can hope to continue in grace—nay, more, that the possession of it in such abundance as we see in Germany entitles a nation to the most respectful appreciation of its neighbours.

If I am successful, in however small a degree, in bringing to light that latent sense of veneration which we must all still feel within our hearts for the gentle Teuton race, and its tender-hearted, sensitive, broad-minded and magnanimous leader, I shall not have compiled this volume in vain.

W.H.R.

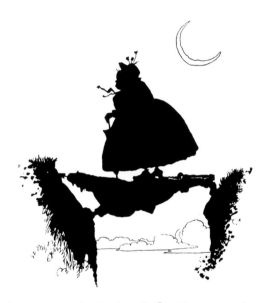

A gallant young student of Stettin assisting a lady
across a chasm

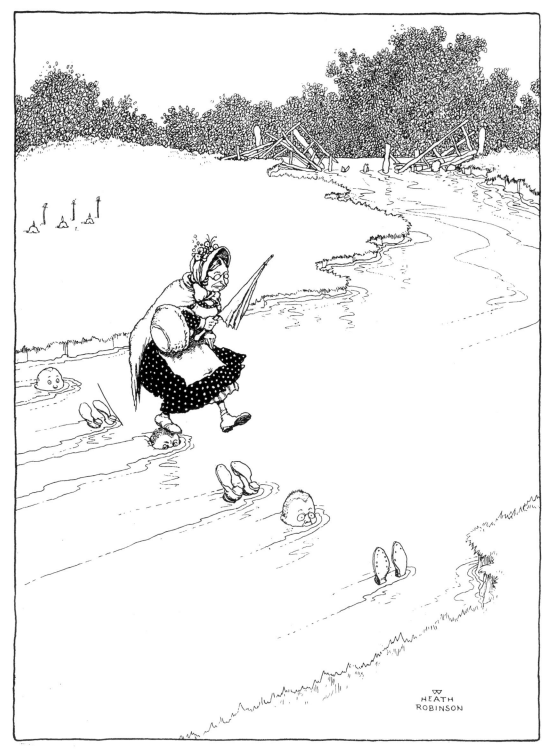

RESPECT FOR AGE

Three thoughtful young Uhlans assisting an elderly lady across the Meuse

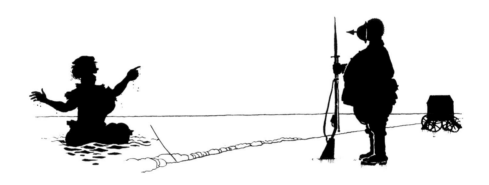

Modesty's device at Ostend

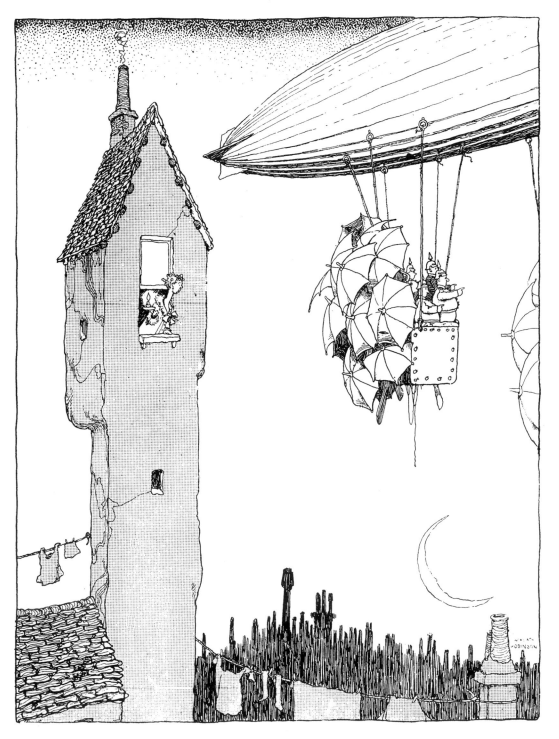

MODESTY

Consummate delicacy of young German aeronauts when passing over
thickly populated areas

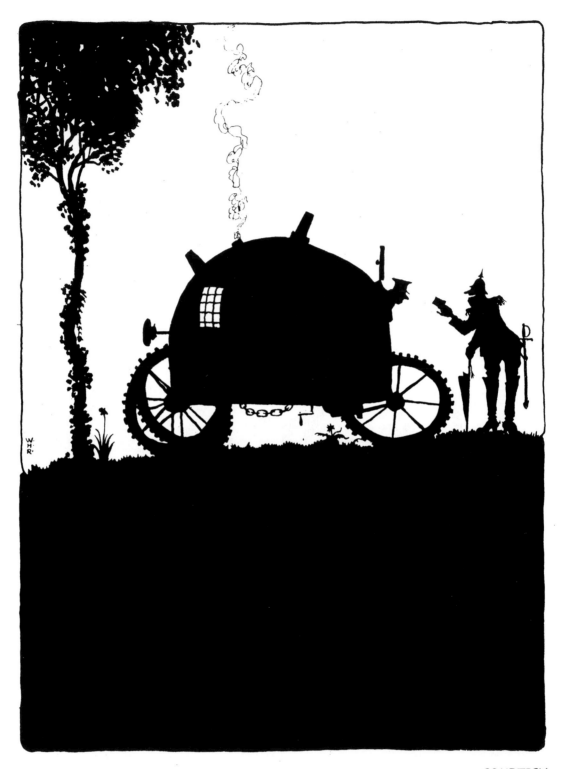

COURTESY

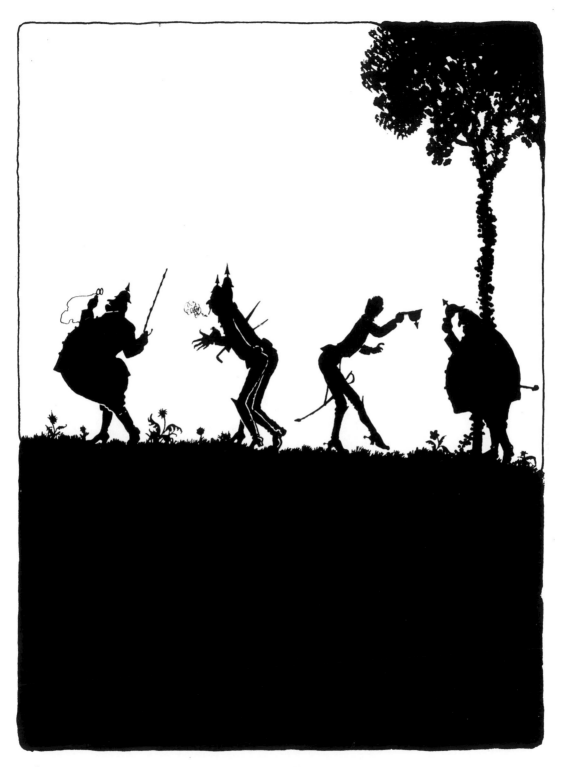

German officers leaving cards on a Tank newly arrived in the district

A noble Hun saving his Kaiser's pet
vulture from starvation

A kindly old Boche training a Hun pet to
jump through his halo

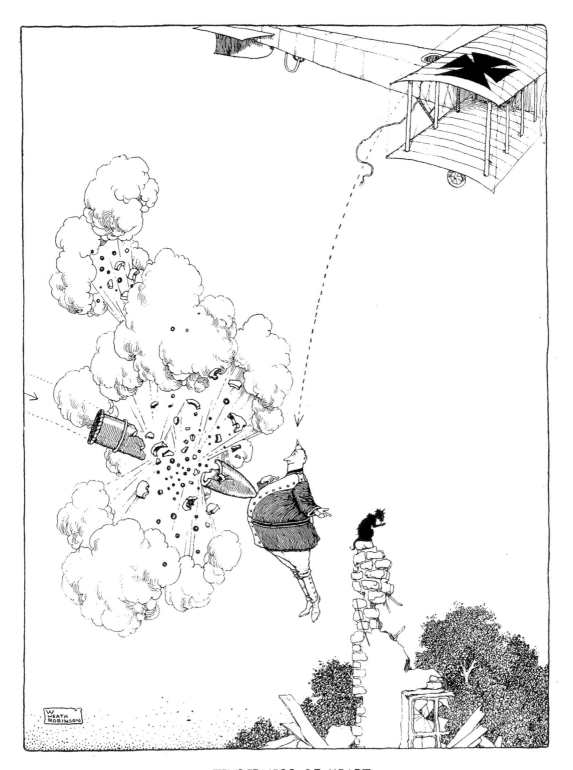

TENDERNESS OF HEART

A plucky young German aeronaut giving his life for that of a dumb friend

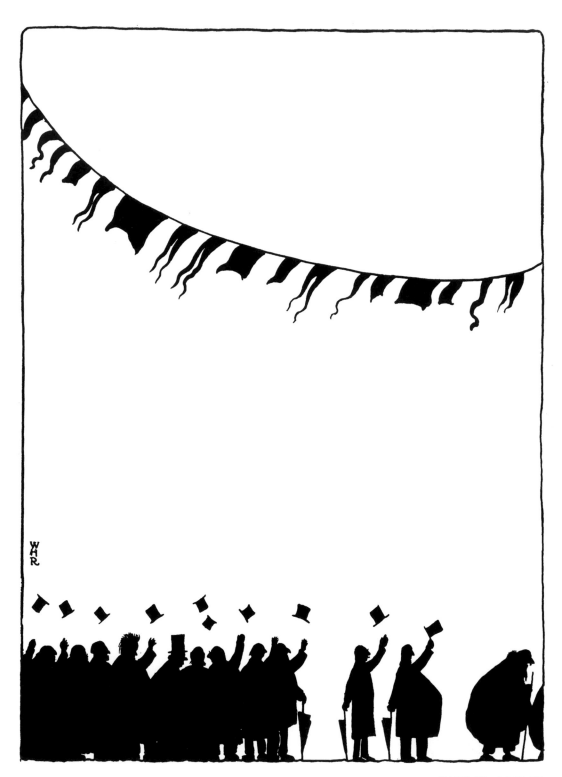

PUBLIC SPIRIT

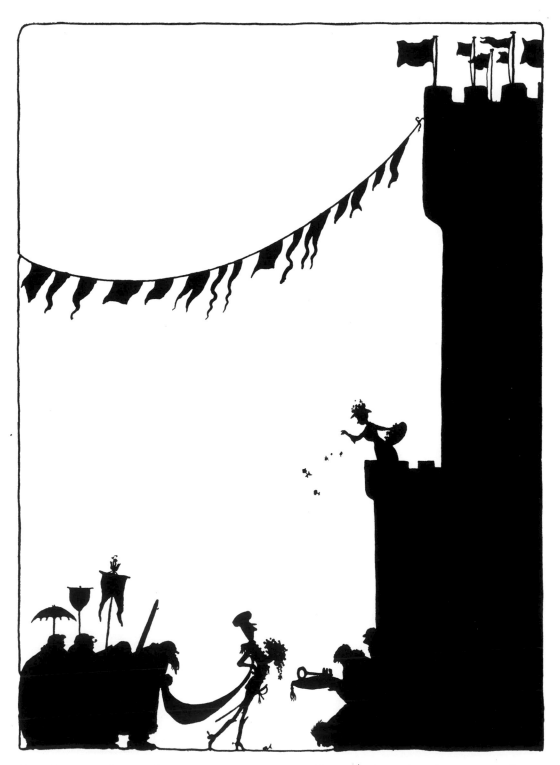

The German Crown Prince opening a new Criminal Lunatic Asylum in Berlin

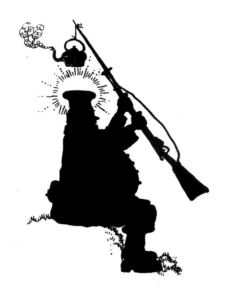

Practical saintliness of a worthy Hun

Jolly decent conduct of a saintly Hun
to his prisoner

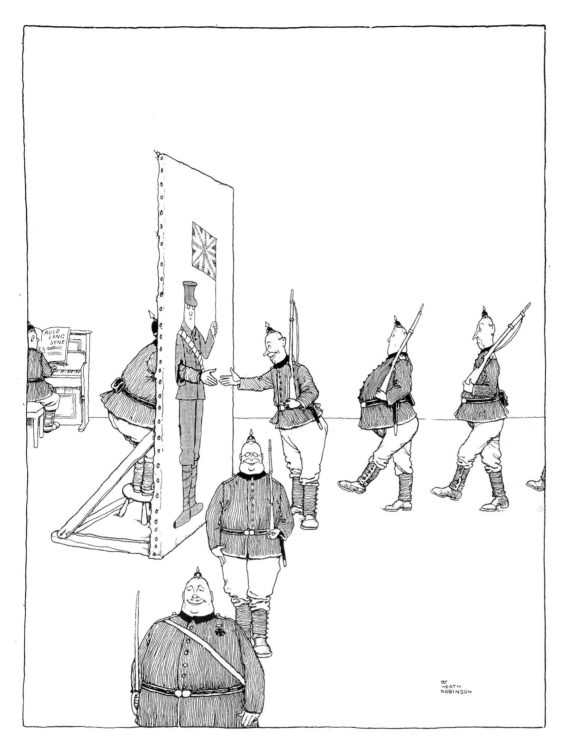

GOOD FELLOWSHIP

German officers training the gentle Boche to regard the British soldier
in a spirit of friendliness

Innocent abandon of spirited young
Boche on coming of age

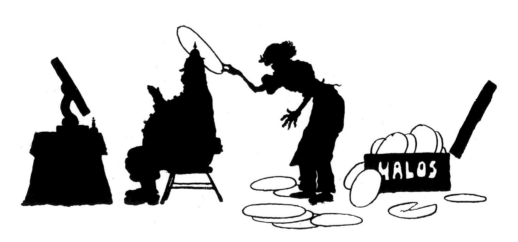

Pardonable vanity of an adolescent Junker on reaching years of saintliness

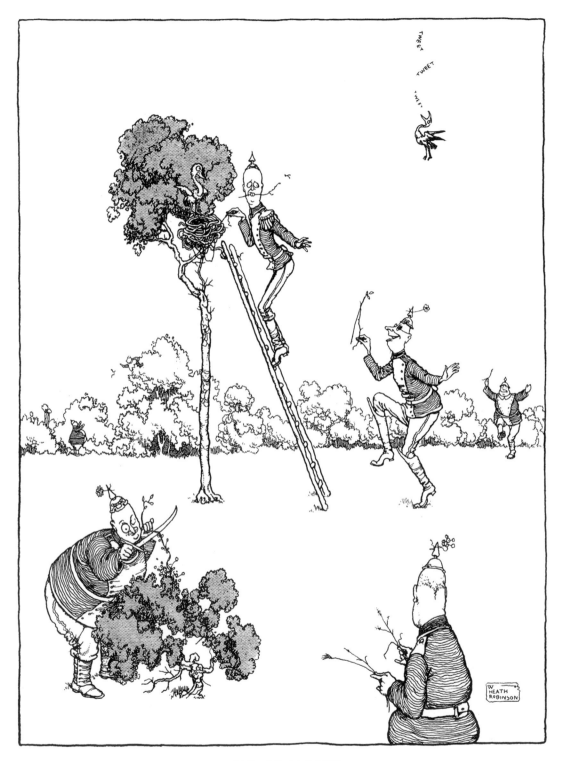

LOVE OF NATURE

German troops in the field helping the young birds to build their nests

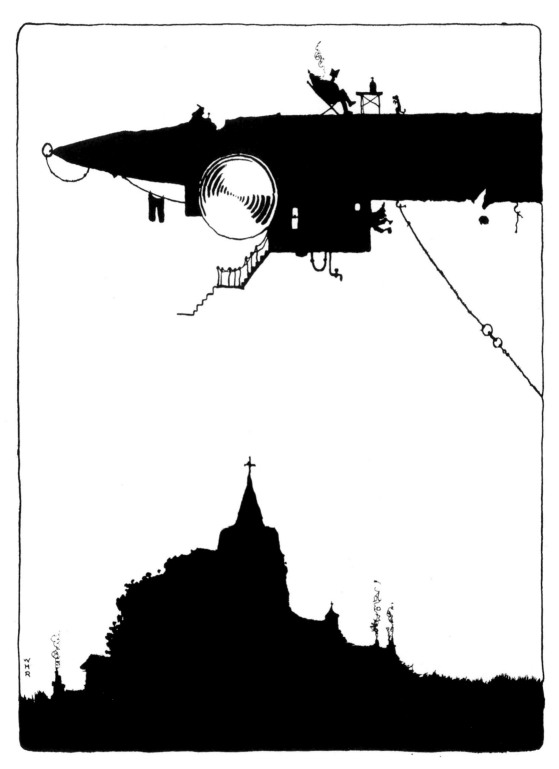

LOVE OF CHILDREN

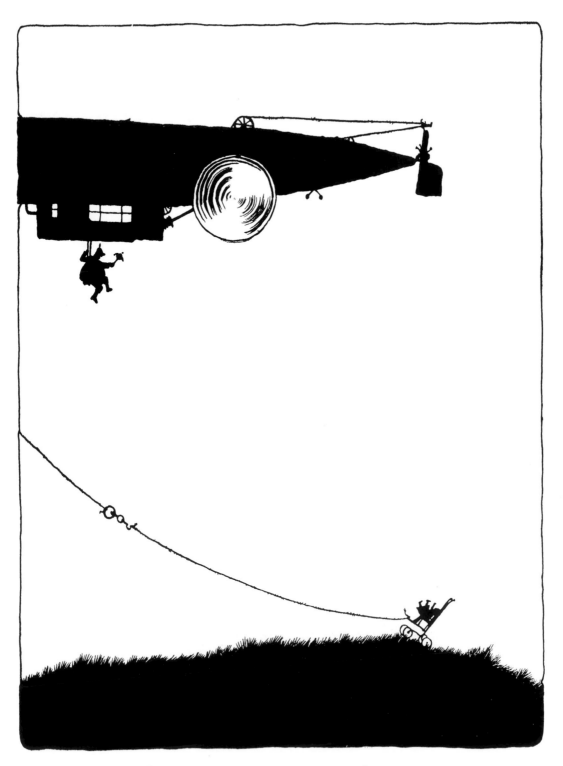

Old dears in a Schütte Lanz taking a peasant's child for a little run

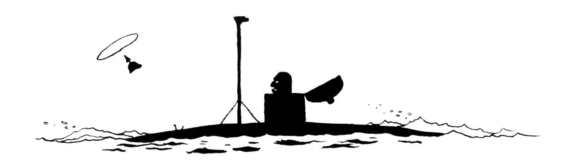

Self-restraint of U-boat officer whose halo has blown off in a high wind

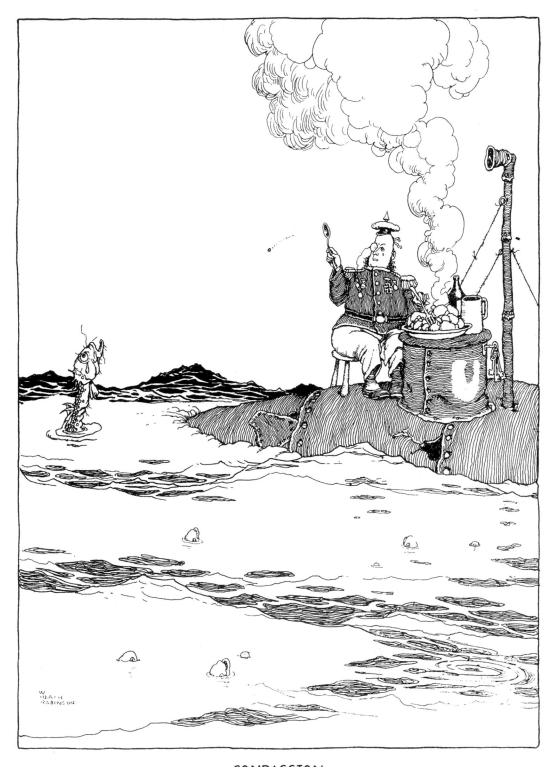

COMPASSION

A noble U-boat commander sharing his rations with a famished hake

Escaped German prisoner honestly admitting his identity
to old lady at Tooting Bec

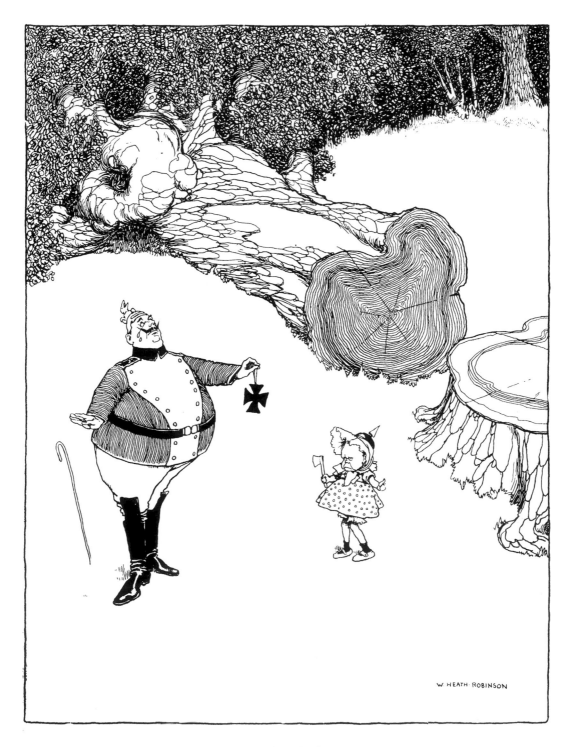

VERACITY

A truthful scion of the House of Hohenzollern frankly owning to a
childish prank in gardens of Potsdam

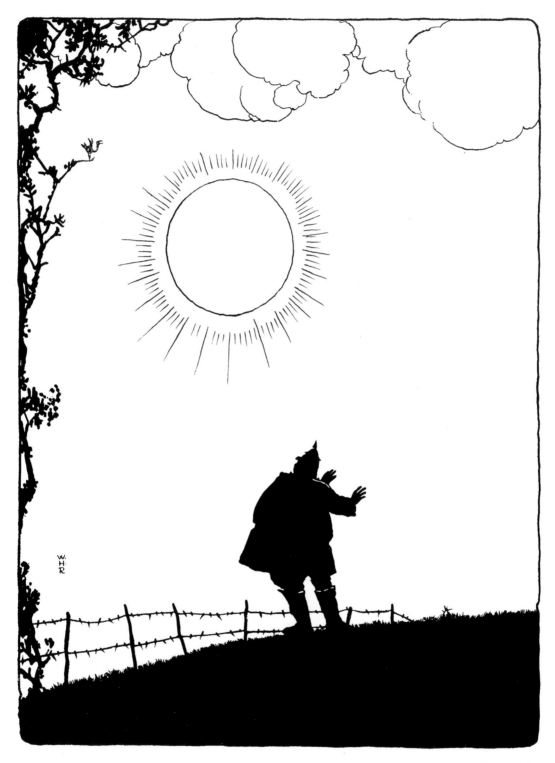

FORTITUDE

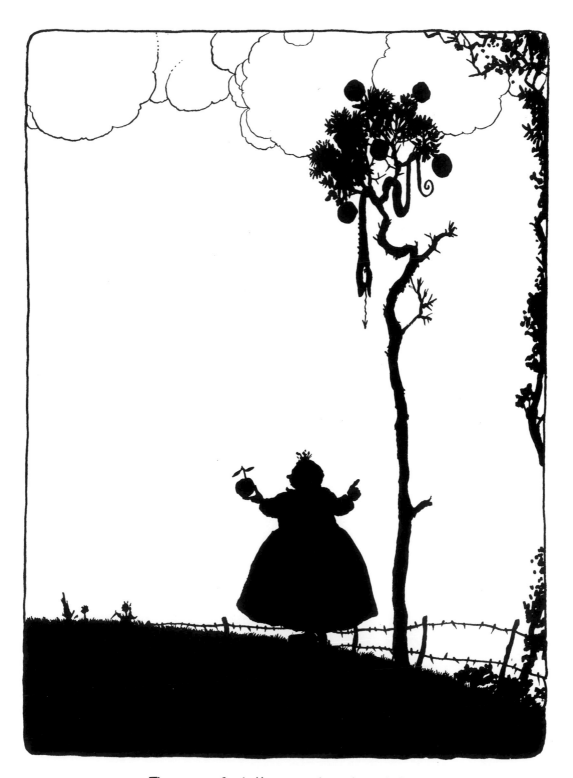

The very first Hun resisting temptation

Beautiful domesticity from the
valley of the Spree

Considerate and benevolent young
German disguised as an automatic
weighing machine collecting money
for public charities at the principal
Berlin termini

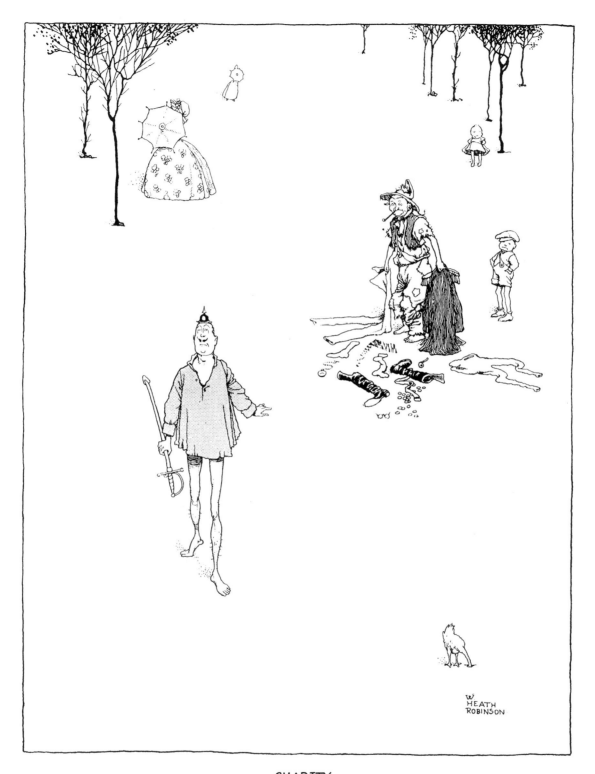

CHARITY
A kind-hearted Prussian officer giving his clothes to a needy Belgian peasant

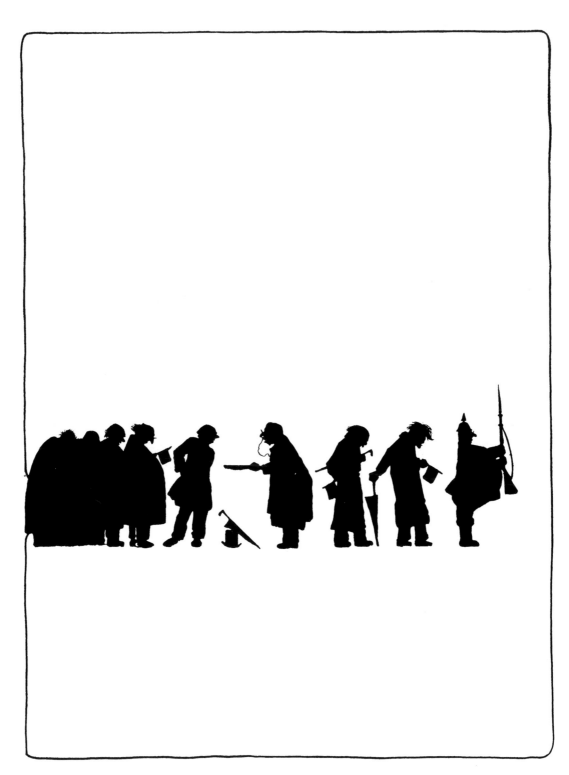

PROPER PRIDE

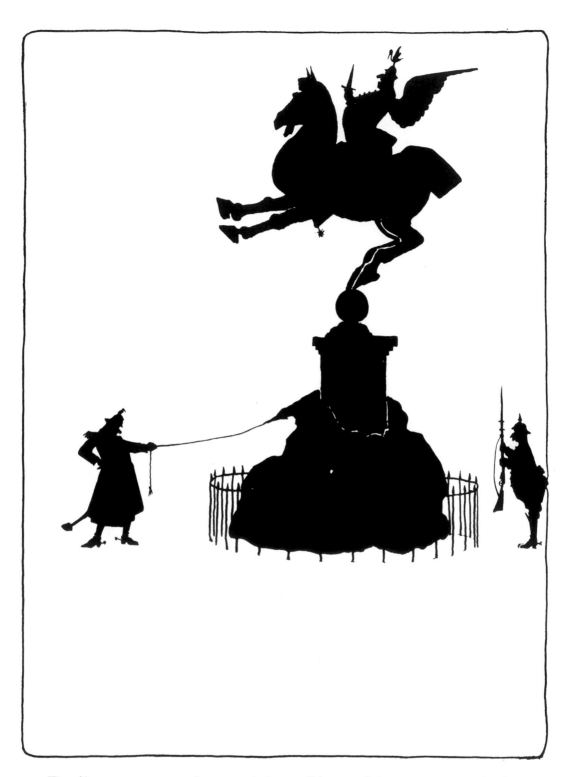

The Kaiser unveiling heroic statue of himself to commemorate his victory over the entire world

A promising young Boche cutting his first wings

The discomfort of wings at bedtime

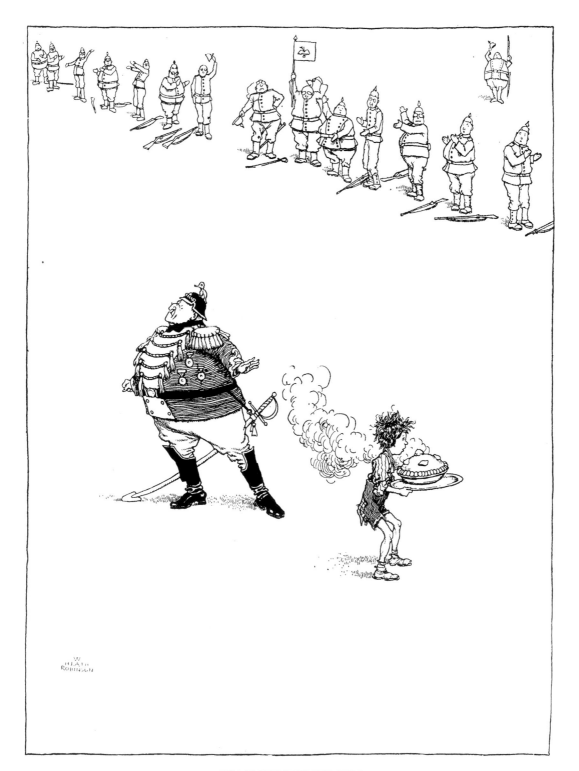

CONSCIENTIOUSNESS
An iron-willed Prussian general butting away from himself the thought of loot

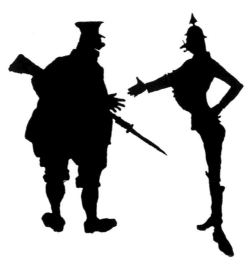

Magnanimous German prisoner congratulating his captor

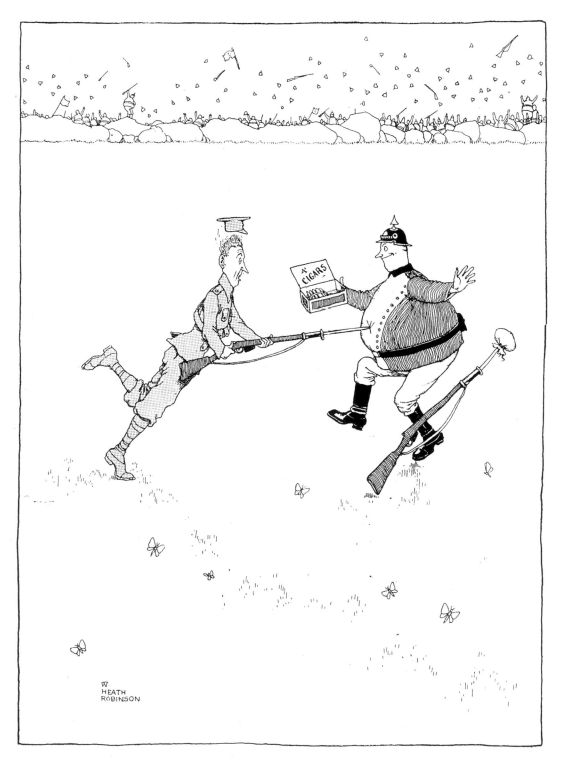

CHRISTIAN SPIRIT
A benignant Boche returning good for evil

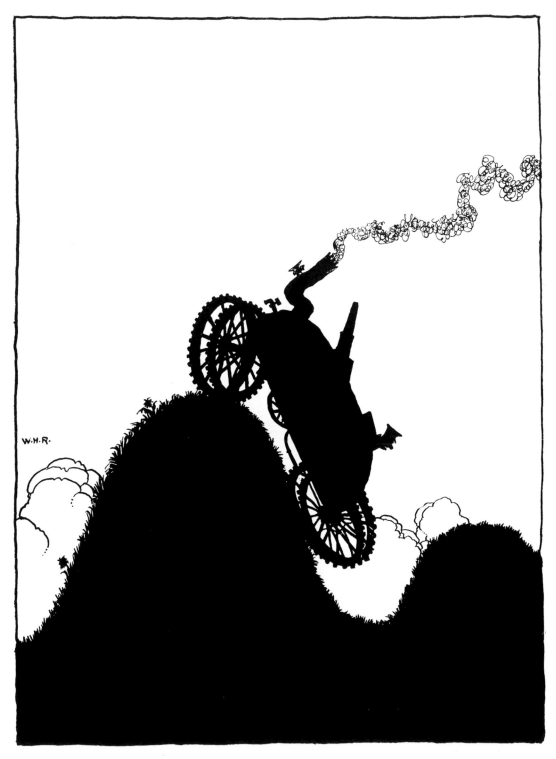

HONEST WORTH

A rough diamond of an old Boche hastening to the relief of an acute
case of *mal de tank*

Exquisite politeness of graceful young Uhlan on the Mall at Mulhausen

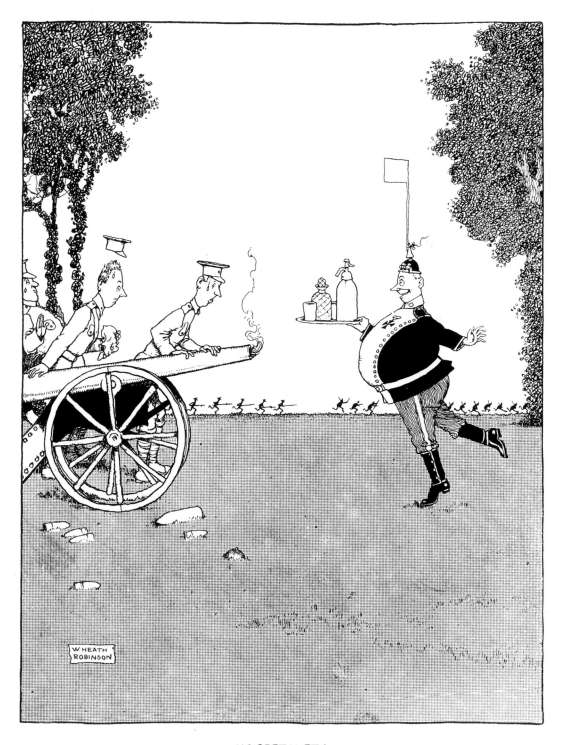

HOSPITALITY

A considerate young Boche, under a flag of truce, bringing light
refreshments to our troops

A fair-minded young Teuton declining to poison a well in East Africa

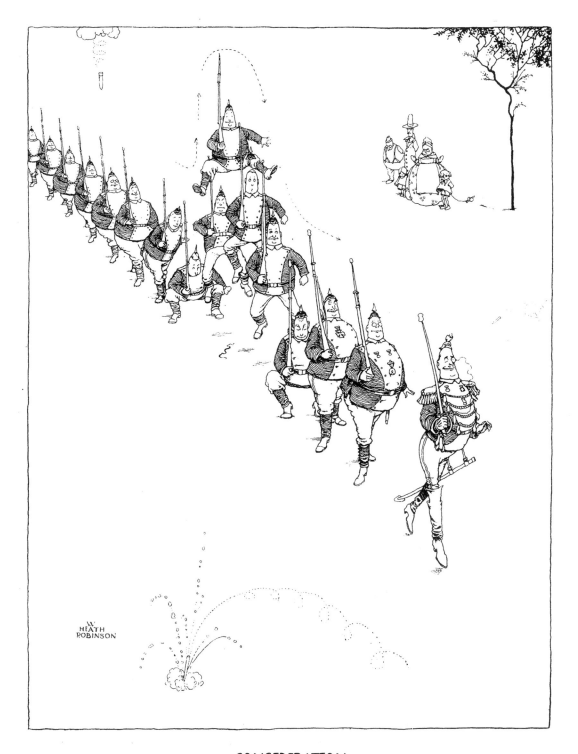

CONSIDERATION

The soft-hearted Brandenburgers refusing to tread on a worm on their way to the trenches

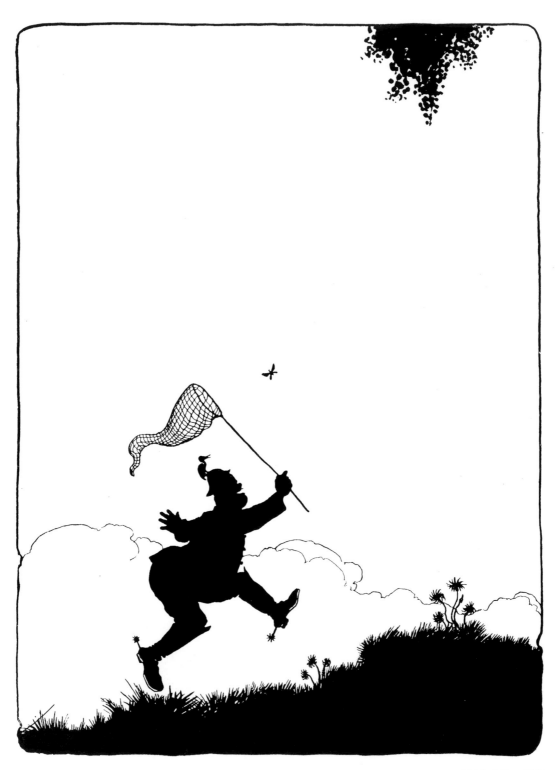

JOY OF LIFE

Von Hindenburg's only hobby

A thoughtful young Stuttgarter sacrificing his dignity for the amusement of a little child

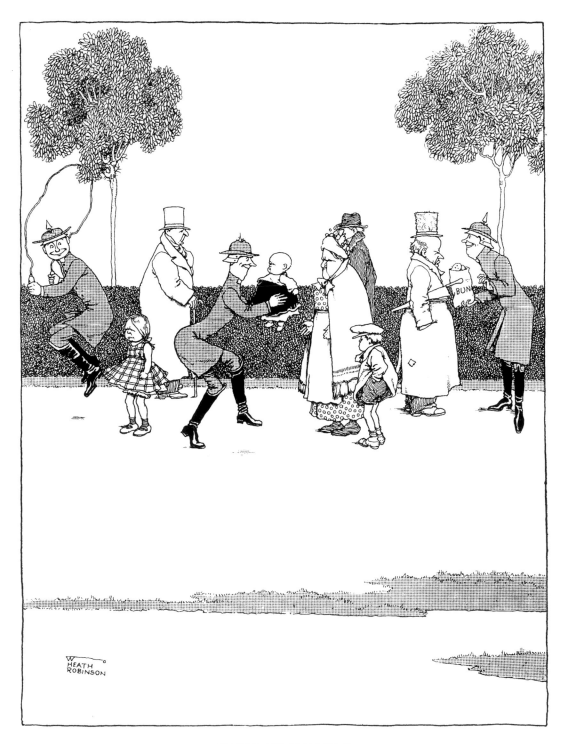

FORCE OF EXAMPLE

Cheery young German officers, disguised as curates, instilling a spirit of
light-heartedness into the civilian population after a great naval victory

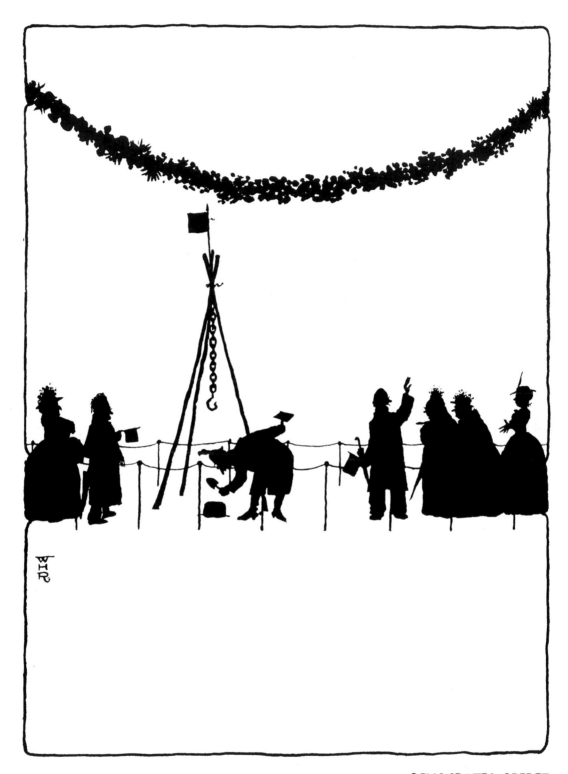

DEMOCRATIC SPIRIT

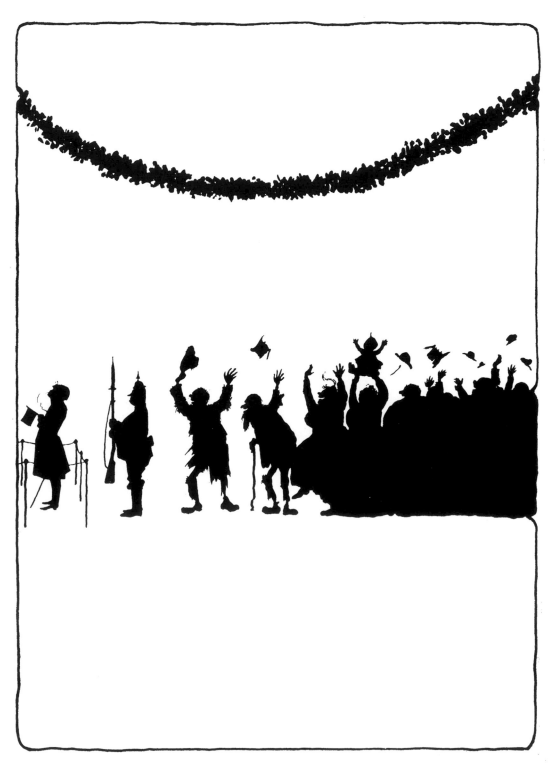

The Kaiser laying the foundation-stone of a new prison to be devoted
exclusively to the lower orders

Slight mistake of a rather overstrung Boche

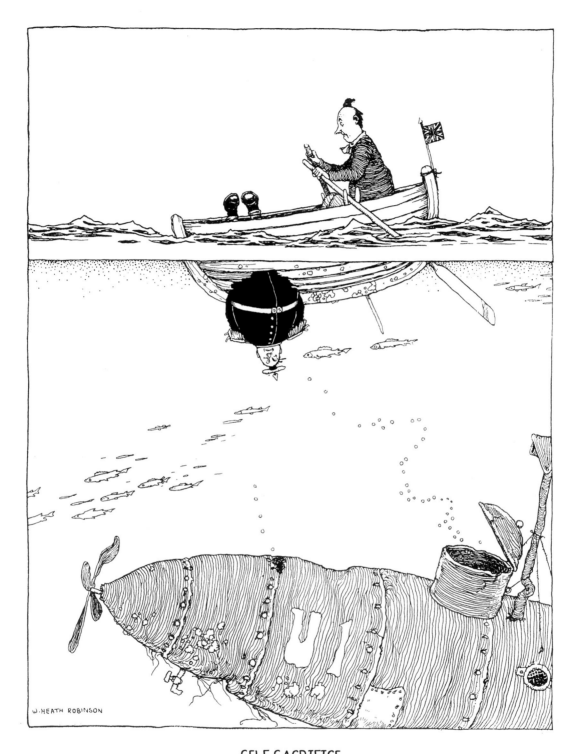

SELF-SACRIFICE

An heroic U-boat commander plugging a leak which he had inadvertently
made in an English vessel in the North Sea

VALHALLA